ART HEIST

Quarto

First published in 2024 by Ivy Press,
an imprint of The Quarto Group.
One Triptych Place
London, SE1 9SH,
United Kingdom
T (0)20 7700 6700
www.Quarto.com

A catalogue record for this book is available from the British Library.

ISBN 978-0-7112-8793-8
Ebook ISBN 978-0-7112-8795-2

10 9 8 7 6 5 4 3 2 1

Design by Ginny Zeal

Publisher: Richard Green
Editorial Director: Jennifer Barr
Senior Designer: Renata Latipova
Editor: Katerina Menhennet
Editorial Assistant: Nayima Ali
Production Controller: Rohana Yusof

Printed in China

ART HEIST

50 ARTWORKS
YOU WILL NEVER SEE

Susie Hodge

W

Contents

Introduction

• Why is art stolen? • Who steals it? • Is it stolen to order? • What do thieves do with stolen art? • Who profits from the theft? • Who buys it? • Is it hidden away in vaults or safes, or displayed on walls in the homes of the obscenely rich?

These questions and more occur to many of us when we think about stolen art. The centuries-old crime of art theft has certain attractions for the prospective thief. Art is unable to fight back, and it is generally quite portable. In the early 21st century, the US Federal Bureau of Investigation (FBI) estimated that $4 to $6 billion-worth of art is stolen around the world each year. After drug trafficking, money laundering and arms dealing, art theft has become the biggest crime category in the world.

Motivation

The perceived value of artworks is often one motivation behind art theft. Another is convenience and moveability. Because many paintings, small sculptures and other artefacts are easily carried, stowed away or concealed, they can be whizzed from a private home or public museum before the police have even been informed. As such thefts, whether from public or private collections, are not usually reported in too much detail, investigators rely on the vigilance both of art dealers and the public to report sightings of stolen art or any suspicious activity they may observe, as this helps to prevent, or at least slow this type of crime. The Art Loss Register helps to prevent art theft by reducing the sale of stolen art. Anyone who is a victim of art theft can contact the Art Loss Register and once listed there it is extremely difficult for the stolen art to be sold in the legitimate art market. Most respectable auction houses, galleries, museums and other buyers consult the Art Loss Register and would inform the police if any work came up which they suspected was stolen.

During times of war, widespread looting often occurs. This happened on a grand scale during the Napoleonic Wars in the early 19th century, and during the Second World War in the mid-20th. Artworks stolen by the Nazis have since been found in major museum collections, and many descendants of the

OPPOSITE, TOP: An empty frame in the Isabella Stewart Gardner Museum, Boston, which was the scene of one of the most infamous art heists in history.

OPPOSITE, BOTTOM: Almost all galleries employ security guards to safeguard the artworks.

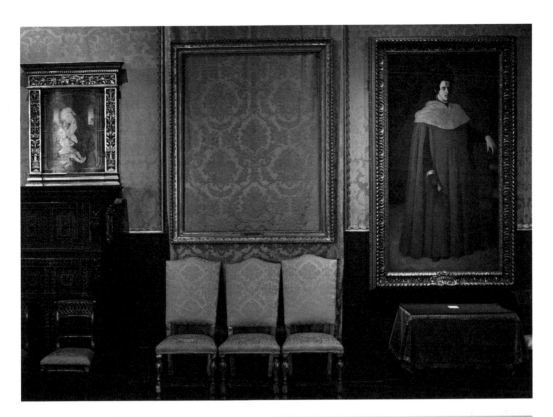

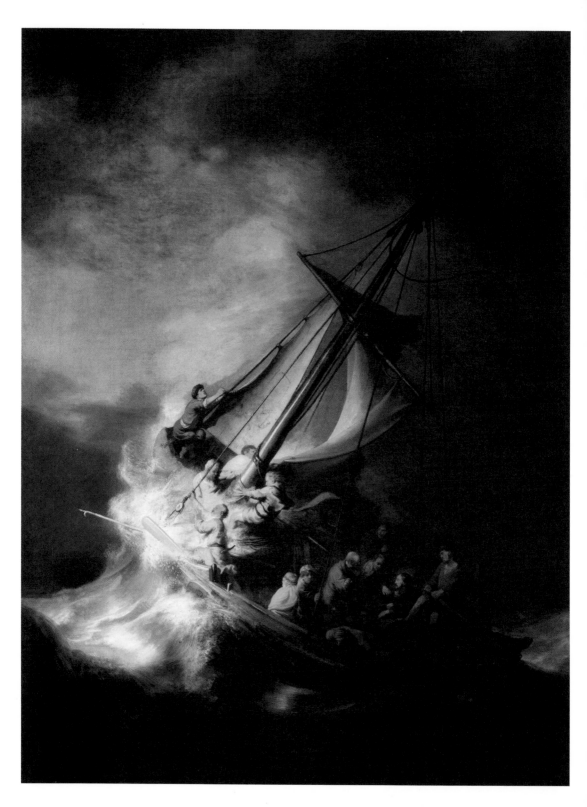

original victims continue to pursue legal action to regain ownership of these works.

Plundered art can be sold to unscrupulous individuals who are aware that they are buying stolen goods and are comfortable taking the risks that come with the handling and possession of such items. In the art world, these secret collectors are called 'gloaters'. Other works may be hidden until the thieves deem that their notoriety has died down sufficiently and a discrete sale may be possible. Still others are destroyed when the thieves realise that the reputation of the works is such that the scandal around their theft will never diminish. Sometimes, art is stolen specifically as a bargaining tool, to barter for the reduction of a convicted criminal's prison sentence.

The value of art

Art can be valuable for many reasons, and its worth can rise and fall vastly depending on who wants it, who made it, who has previously owned it and a variety of other factors. Rich and powerful people often buy art to demonstrate their wealth and good taste, so its price is linked to status and prestige. That in turn is affected by fashion, which may be driven by appearances in the media, or in a big public exhibition, or another artist's work of a similar style becoming popular. There have been ups and downs in the art market, but since the 1960s there has been a steady upward trend. New records in art values are reported almost every month.

It is rare for an artwork's value to plummet; this usually only occurs if the artist's reputation becomes damaged, whether posthumously or during the artist's life. Unhelpfully for art thieves, if a work of art becomes publicised for being stolen, often its value can rise astronomically. This happened in the case of the *Mona Lisa*, painted by Leonardo da Vinci (1452–1519) in c. 1503–06. The portrait was propelled to international renown in 1911 when it was stolen from the Musée du Louvre in Paris, France. The thief, Vincenzo Peruggia, later described his actions as those of an Italian patriot moved by the belief that the painting should be in Italy, and not in France. It was eventually returned to Paris in 1914. The theft and recovery provoked an exceptional level of publicity and led to the production of an opera, two films and a song. The *Mona Lisa* is now one of the most valuable paintings in the world. If a work of art becomes more valued through the notoriety surrounding its theft, then thieves have little chance of selling it on. Peruggia, for example, kept the *Mona Lisa* hidden for two years while he waited for the furore about the burglary to die down. He finally tried to sell the painting in December 1913, but this only led to his almost immediate arrest.

OPPOSITE: *The Storm on the Sea of Galilee* painted by Rembrandt van Rijn in 1633 was stolen by thieves in March 1990.

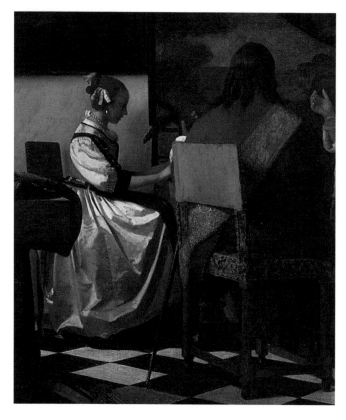

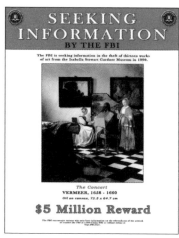

Recovery

Art theft has occurred on scales both small and vast, and been carried out by individuals, gangs and entire armies. This book looks a wide range of thefts, both geographical and chronological. Most of the art and artefacts discussed here have never been recovered. It is likely that some have ended up in private homes or have been destroyed, and many of the perpetrators have gone to their graves without ever revealing the works' whereabouts. These cases often remain open; with international organisations, both public and private, continuing to actively pursue any new leads. For some of the heists, rewards are still being offered for any information that will lead to the recovery of the artworks – and the arrest of the crooks who took them.

The international police agency INTERPOL currently lists 25,000 stolen and unrecovered works of art. INTERPOL and several other agencies, including the FBI Art Crime Team, London's Metropolitan Police Art and Antiques Unit and New York Police Department's special frauds squad continue to investigate and try to recover these works of art and return them to their rightful owners, but it is by far from easy.

ABOVE, LEFT: Possibly the most valuable stolen object in the world, *The Concert* (believed to have been produced some time between 1658–66) is by Dutch artist Johannes Vermeer and features his skilful depiction of light.

ABOVE, RIGHT: Poster produced by the FBI, 'Seeking Information' about the thirteen stolen artworks from the Isabella Stewart Gardner Museum, and offering a $5 million reward for any information leading to the recovery of the works.

This book presents some of the most intriguing art heists of all time. It explores thefts of individual works of art, of entire collections of art and artefacts, of repeated thefts of just one artwork, and the attempted theft of entire countries' cultures through their art and artefacts. The tales are intriguing, fascinating, and sometimes shocking. They are true stories of what happened, but the story is often not yet complete, because all, or nearly all, of the works of art discussed in the book remain missing. The hunt by police, detectives and other agents to locate them and return them to their rightful owners continues. Police, detectives and other agents have not been able to find them and return them to their rightful owners, despite speculation, in-depth and extensive investigation, and many leads which turned out to be false.

Many of us have an interest in missing works of art and artefacts. They shed light on our collective past, our heritage, and are windows into the lives of those who lived before us. These works are examples of humanity's creativity; aspects of the human race that make us unique. They are usually created to evoke pleasure, to give us insights into other people's lives and outlooks or experiences, examples of human endeavour and skill, and they enrich our world. So when they are stolen, the damage the thieves do to us all is really quite immeasurable.

BELOW: During the second World War, in 1943, the Monuments Men – a special unit of Allied servicemen and art experts – helped to recover works of art stolen by the Nazis.

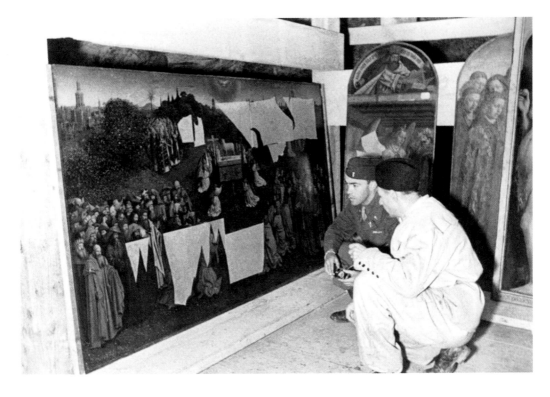

1 Lost

The following pages take you through several accounts of art heists in which the stolen artworks have never been recovered, the crimes never solved. There is much conjecture and supposition about every case, as experts and amateurs alike speculate and scrutinise the facts. Frequently, stolen artworks assume celebrity status once the theft is made public, and so they become 'hot potatoes' and the unscrupulous thieves cannot move them on. It is likely then, that many of the works have been damaged, destroyed, lost or hidden beyond reach. There is not always an obvious reason for particular artworks to have been stolen. Often, they are not the most important works in a collection. While many of us may have the idea that artworks are stolen to order for rich James Bond-type villains, this is rarely the case. It is often rather that many are stolen as bargaining tools by criminals for their colleagues in jail. However, there are many different reasons for such heists, some of which may never be known or understood, and as you will see, many of the stolen works simply disappear without trace. Read on for some of the most incredible, sometimes mind-boggling, often perplexing and infamous art heists of all time.

Nazi Plunder

The Nazi regime led by Adolf Hitler is infamous for
its horrific crimes against humanity during the
Second World War (1939–45).

A less-well-known aspect of its tyranny was the widespread looting
of cultural heritage, mainly from Jewish people, but also from
galleries, museums, churches, palaces and other private individuals
in countries which the Germans occupied.

When Hitler came to power in Germany in 1933, persecution
of the Jews began immediately, with property seizure known as
'Aryanisation'. German-Jewish art collectors and dealers who
did not escape their homeland in time were murdered and their
belongings stolen. Many who did flee were detained when the
German army invaded the countries they had escaped to, and
their possessions were seized by Nazi looting organisations. Among
the stolen treasures were masterpieces by renowned artists such as
Vincent van Gogh (1853–90), Michelangelo (1475–1564), Albert Gleizes
(1881–1953), Raphael (1483–1520), Johannes (Jan) Vermeer (1632–75),
Peter Paul Rubens (1577–1640), Rembrandt van Rijn (1606–69), Franz
Marc (1880–1916), Egon Schiele (1890–1918), Gustav Klimt (1862–1918),
Max Liebermann (1847–1935) and Jean Metzinger (1883–1956).
Some artworks were sold to finance the Nazi war machine, some
were retained for Hitler's planned German art gallery, some were
destroyed and others entered the private collections of Nazi officials.

This organised Nazi plunder has its own name in German:
Raubkunst. During their 12 years in power, from 1933–45, the Nazis
seized roughly 650,000 works of art from across Europe, an
estimated 20 per cent of the entire continent's artwork. The exact
number is uncertain as most of the stolen art was not catalogued or
registered. While many works were recovered after the war, mainly
by the Allies' Monuments, Fine Arts and Archives programme (MFAA,
also known as the Monuments Men) that was formed by President
Franklin D. Roosevelt in 1943, approximately 30,000 are still missing
or were returned to the countries from which they were looted, but
not to their original, rightful owners. The international effort
continues to identify goods stolen by the Nazis that remain
unaccounted for.

OPPOSITE: A selection of
the looted artworks.

Still Life, Albert Gleizes, 1911

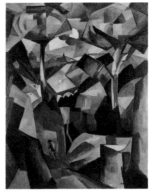

Le Chemin, Paysage à Meudon, Albert Gleizes, 1911

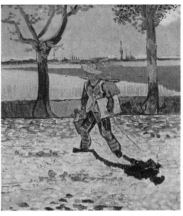

The Painter on the Road to Tarascon, or Painter on His Way to Work, Vincent van Gogh, 1888

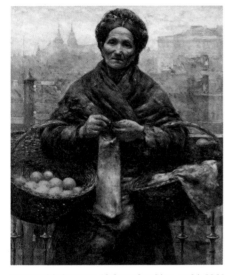

Jewess with Oranges, Aleksander Gierymski, 1881

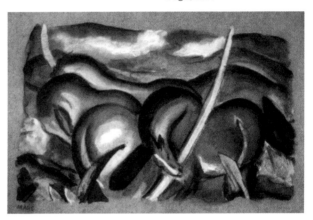

Horses in the Landscape, study, Franz Marc, 1911

En Canot, Jean Metzinger 1913

Portrait of a Young Man, Raphael c. 1513-14

All property owned by Jews in Germany, including artworks, artefacts and valuable furnishings, was seized as part of the Nazi regime's anti-Jewish policies. As the Nazis invaded other countries, they also steadily looted the cultural heritage of their new conquests. This led to a lot of movement of art. German representatives of the Nazi party sold large numbers of artworks in European art centres that had been stolen from Jews, such as more than one million seized items which went under the hammer at a single French auction house in 1941–42. Many looted artworks were destined for a large art museum which Hitler planned to open in Linz, Austria, where he grew up, which was to be called the Führermuseum. During the war, the works he decided would be displayed there were stored in several safe locations, such as Neuschwanstein Castle in Bavaria and the Altaussee salt mine in Austria.

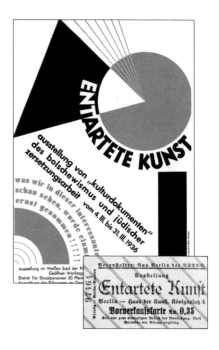

Degenerate art

Nazi ideology had a complex relationship with art. Hitler was a failed artist, who as a young man had been

BELOW: The opening of the Degenerate Art Exhibition in Berlin in 1937.

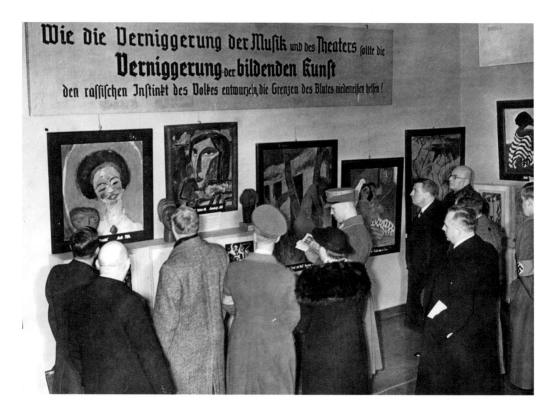

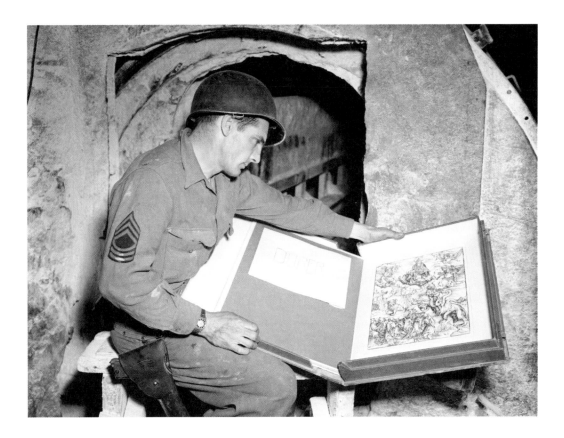

twice rejected from the Academy of Fine Arts in Vienna and subsequently, he resented many successful artists of his time. His taste in art was restricted to a rather bland and narrow figurative style that he believed conveyed his vision of a pure Aryan race. He hated modern and abstract art, dismissing it as 'degenerate' – a term he used to condemn anything that did not conform to his limited outlook. He especially hated art by Jewish artists. Believing himself an art expert, he launched a savage attack on modern art in his 1925 autobiographical manifesto *Mein Kampf* (*My Struggle*). In 1933, when he became Chancellor of Germany, he forced his aesthetic ideal on the nation, demanding that all 'degenerate' art in Germany's state museums – amounting to approximately 20,000 artworks – should be sold or destroyed.

Four art dealers, Hildebrand Gurlitt, Karl Buchholz, Ferdinand Möller and Bernhard Böhmer, were appointed by the Nazi Commission for the Exploitation of Degenerate Art to sell confiscated works of art abroad. They also established a shop just outside Berlin, to sell some of the hoard that had been removed from German museums. Additionally, in 1937, Hitler held The Great German Art Exhibition in Munich, which showcased works that had

ABOVE: An American GI inspects a looted Albrecht Dürer print in the Merkers salt mine complex, c. 1945.

OPPOSITE, TOP: Hitler's closest associate and Reich of Minister of Propaganda, Joseph Goebbels, came up with the project of *Entartete Kunst* (*Degenerate Art*).

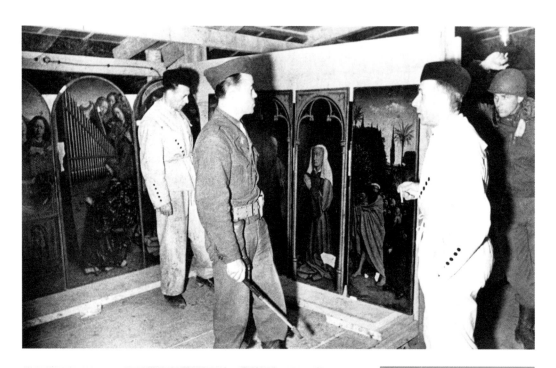

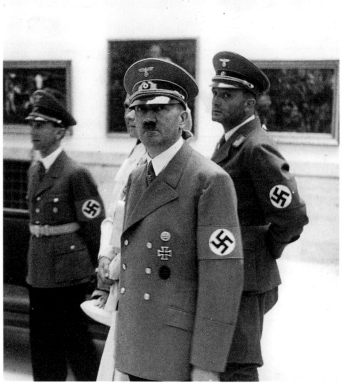

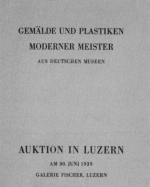

BOTTOM, LEFT: Hitler and his associates at the Degenerate Art Exhibition.

BOTTOM, RIGHT: On 30 June 1939, Galerie Theodor Fischer in Luzern (Lucerne) organised the auction 'Gemälde und Plastiken Moderner Meister aus Deutschen Museen' (Paintings and Sculptures of Modern Masters from German Museums). One hundred and twenty-six artworks were offered for sale.

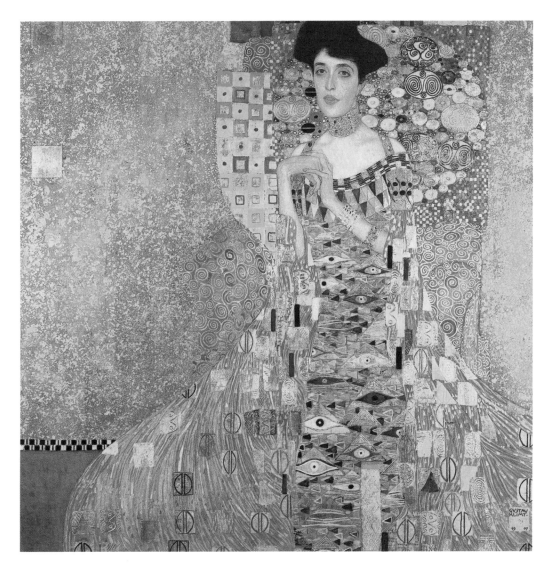

been commissioned by the Nazi regime; works that were figurative, neat and static. Approximately 600,000 visitors attended the exhibition. Along with seven other similar exhibitions, there were 12,550 exhibits on show in total. Hitler bought a lot of the artworks, but international interest was low. The Degenerate Art Exhibition, which was held simultaneously in Munich, displayed 740 of the artworks that had been taken from museums. Among them were works by artists such as Pablo Picasso (1881–1973), Paul Gauguin (1848–1903), Henri Matisse (1869–1954), Wassily Kandinsky (1866-1944), Albert Gleizes (1881–1953), a pioneer of Cubism, and Franz Marc, a key figure in the German Expressionist movement. At the time, Hitler declared: 'The artist does not produce for the artist, he

ABOVE: *Portrait of Adele Bloch-Bauer I*, Gustav Klimt, 1907.

OPPOSITE, TOP: Monuments Men examining Jan van Eyck's Ghent Altarpiece at the Altaussee Salt Mine in Austria in 1945.

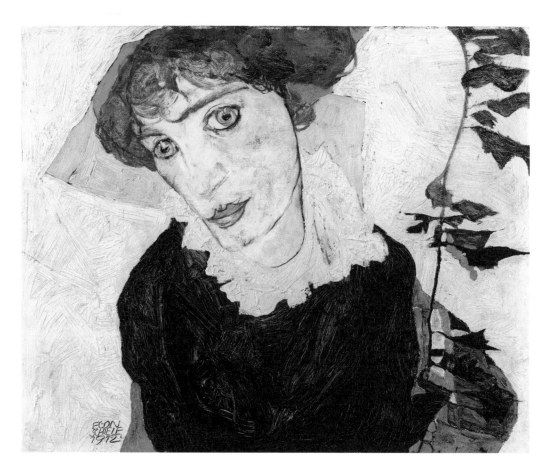

produces for the people, just as everybody else does! And we are going to take care that it will be the people who from now on will again be called upon as judges over its art ...' The Degenerate Art Exhibition drew record crowds; two million visitors passed through the doors. All were encouraged to mock the condemned artworks, which propagandist Joseph Goebbels described as 'garbage' in a radio broadcast. The exhibition toured 11 German and Austrian cities. Yet the terms 'degenerate' and 'garbage' badly affected sales, and in March 1939, 1,004 paintings and sculptures and 3,825 watercolours, drawings and prints were tossed on to a bonfire, under the supervision of the Berlin Fire Department. They included works by Picasso, Georges Braque (1882–1963), Fernand Léger (1881–1955), André Masson (1896–1987) and other important artists. Hearing of the destruction, horrified art lovers from neutral Switzerland bought what they could, and Gurlitt, Buchholz, Möller and Böhmer kept many for themselves, while also selling some to American buyers. In the summer of 1939, the Grand Hotel National in Lucerne, Switzerland became the venue for what was called an

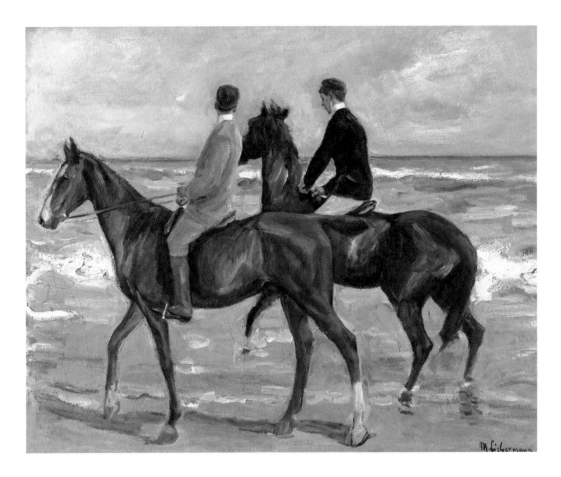

auction 'of degenerate art'. There, under the hammer, 126 pillaged artworks were sold at low prices. They included a portrait by van Gogh, four paintings by Picasso and others by Gauguin and Matisse.

Public, private and personal collections

After taking art from state-run museums and galleries, the Nazis began ransacking the art collections of private owners. All Jews were stripped of their assets. The Nazis either seized the goods directly, or confiscated them under the pretext of special 'art protection' units known as the *Kunstschutz*.

Nazi forces also looted art from countries they invaded or occupied, including Austria, Poland, France, Czechoslovakia, Hungary, Belgium, the Netherlands, Luxembourg and Ukraine. Towards the end of the war, they even stole art from their former ally Italy, removing approximately half of Florence's art collections from the Uffizi Gallery and the Pitti Palace. In the Soviet Union, where even though Germany had pledged non-aggression, German troops plundered cultural centres, museums, palaces and cathedrals,

ABOVE: *Two Riders on the Beach*, Max Liebermann, 1901 – this painting, which is in a Private Collection, is similar to another painting by Liebermann of the same title and subject that was stolen by the Nazis in 1938.

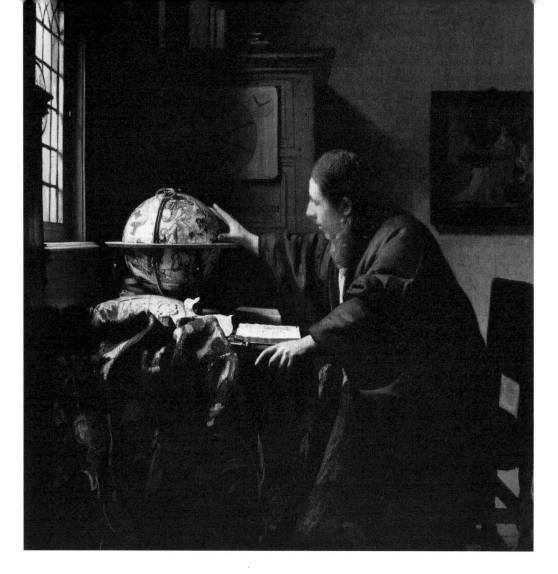

helping themselves to hundreds of thousands works of art and
artefacts. Entire art collections with significant value were
confiscated from prominent Jewish families, including the
Rothschilds, the Rosenbergs, the Wildensteins and the Schloss
family. They included paintings by prominent artists such as
François Boucher (1703–70), Jean-Baptiste Siméon Chardin (1699–
1779), Jean-Honoré Fragonard (1732–1806) and Lucas Cranach the
Elder (c. 1472–1553).

Austria, with its rich artistic heritage, was another major victim
of Nazi art theft, following the *Anschluss*, its annexation in 1938 by
Germany. Gustav Klimt, one of the most important members of the
Vienna Secession movement, was a particular target. His 1903–07
painting, *Portrait of Adele Bloch-Bauer I*, was seized from the Bloch-
Bauer residence in 1941. Egon Schiele, another Austrian artist known

ABOVE: *The Astronomer*,
Johannes Vermeer, c.
1668 – another
masterpiece seized by the
Nazis, which was later
recovered from the
Altaussee salt mine and
returned to the
Rothschilds after the war.

Q THE AMBER ROOM

A spectacular chamber, the Amber Room (pictured below) was in the Catherine Palace of Tsarskoye Selo, near Saint Petersburg in Russia. Decorated with carvings and mirrors, it was also embellished with gold leaf that shone through the lustrous amber panels that lined the walls. By day, rich golden colours and reflections were admired by visitors, and by night, it glittered sumptuously in the glow of 565 candles. The room was designed from 1701–07 by the German Baroque sculptor Andreas Schlüter and the Danish amber craftsman Gottfried Wolfram. Their work was completed by the amber artists Gottfried Turau and Ernst Schacht when they became responsible for the project after 1707. The chamber's reputation was such that it was frequently described as the 'Eighth Wonder of the World'. It remained in the Charlottenburg Palace in Berlin until 1716, when Tsar Peter the Great visited and so admired it that the Prussian King Frederick William I gave it to his ally as a gift. Back home, Peter had it installed in the Catherine Palace, where, with further additions and changes, the room eventually covered over 55 square metres (590 square feet).

Soon after the Germans invaded the Soviet Union in June 1941 during the Second World War, the curators responsible for removing the art treasures in Leningrad (as St Petersburg was by then called) tried to dismantle the Amber Room, but the amber had become brittle with age and began to crumble. So instead, in an attempt to prevent the advancing German forces from seizing it, the whole room was hidden behind ordinary-looking wallpaper. Unfortunately, the ploy did not work, and within 36 hours, German soldiers had dismantled the room, packed it all into 27 crates, and piled these onto trucks. The amber panels reached Königsberg Castle in East Prussia by October 1941. The following month, a local newspaper announced an exhibition of the Amber Room at the castle. Some years later, in January 1945, the looted objects were moved from Königsberg on Hitler's orders.

Yet before the Amber Room could be moved, Erich Koch, who was in charge of civil administration in Königsberg during the final months of the war, abandoned his post and fled. Confusion followed, and the city was heavily bombed. It is not clear what happened, but after the war, the Amber Room was nowhere to be found. The fate of the panels remains a mystery. Theories range from their being bombed during the war, to them being shipwrecked in the Baltic Sea while being moved to another location.

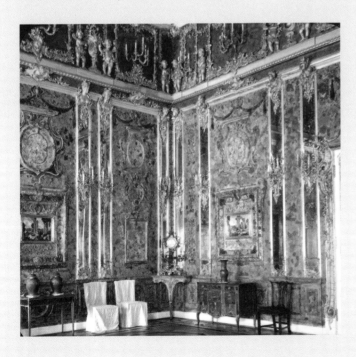

for his raw and explicit depictions of sexuality, was also targeted, despite his work's dissonance with Nazi ideals. His 1912 *Portrait of Wally Neuzil* was owned by a Jewish art dealer who had given up the painting under duress to art dealer and Nazi party member Friedrich Welz in 1938, before then fleeing the country to escape the Aryanisation programme.

Over the duration of the war, the Nazis seized or illegitimately acquired over one-third of all the art in French private collections. Even German artists were not immune from Nazi plundering. Max Liebermann, a German-Jewish painter and printmaker, and one of the leading proponents of the Impressionist movement in Germany, had his works confiscated because of his Jewish heritage. His 1901 painting *Two Riders on the Beach* was seized from his granddaughter's private collection in 1938.

In 1939, the children of the German-French art connoisseur, Adolphe Schloss (1842–1910) sent his art collection for safe-keeping into hiding in a chateau in Laguenne, in central France. There were 333 paintings in the collection, mainly of Dutch and Flemish origin, including works by Rembrandt, Anthony van Dyck (1599–1641), Frans Hals (1582–1666) and Judith Leyster (1609–60). The Germans began hunting for this highly significant collection of art as soon as they occupied France, and in 1943, they found and seized it, with Hitler taking 262 of the works for himself. In Vienna, meanwhile, the Nazis seized 29 shipments containing nearly 3,500 works of art from the Rothschild banking family, whose palaces contained over 5,000 artworks. Many of the objects were selected by Hitler for his Führermuseum, including *The Astronomer,* a 1668 painting by Jan Vermeer, and a large number of other masterpieces, including works by van Dyck, Fragonard and Raphael.

After the occupation of Poland by German forces in September 1939, the Nazi regime committed genocide against Polish Jews and attempted to destroy Polish culture. Thousands of art objects were pillaged. Twenty-five museums and many other cultural buildings were demolished. It is estimated that almost half of the Polish art patrimony was either destroyed or looted. Altogether, more than 516,000 works of art were stolen. These included 2,800 European paintings, 11,000 Polish paintings, and tens of thousands of sculptures, manuscripts, maps and books, together with hundreds of thousands of other items of artistic and historical value.

Aftermath and Recovery

The Führermuseum never materialised, so many of the artworks intended for that gallery instead entered the personal collections of high-ranking Nazis, such as Hermann Göring. After the war, the

Monuments, Fine Arts and Archives programme (MFAA), often called the 'Monuments Men,' established by the Allies to find and return the stolen artworks to their legal owners, began its work. The MFAA soon discovered that many of the owners had perished in Nazi death camps. However, between 1945 and 1951, an estimated five million items were returned, either to galleries or to individuals or their successors. Work continued over the following decades, as Jewish descendants tried to reclaim their families' plundered possessions. They were often unsuccessful; many of their attempts became embroiled in legal cases, and although many artworks were recovered, thousands remain in the wrong hands or missing.

The Nazi art heists were not merely about acquiring wealth or showcasing power. They were also an attempt to erase cultural identities and rewrite history. The continuing search for the stolen artworks is not merely a quest for justice, but an important effort to restore the cultural heritage of nations as well as humanity's shared history.

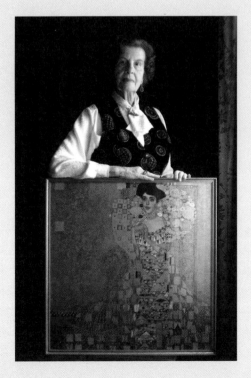

Q LEGAL BATTLES

Most of the process of recovering stolen artworks involved legal battles. Klimt's *Portrait of Adele Bloch-Bauer I* was only returned to Maria Altmann (1916–2011, pictured left), the niece of Adele Bloch-Bauer, in 2006 after a lengthy and expensive court case. In another example, in September 2010, customs officers at the Swiss-German border questioned a man travelling from Zurich to Munich. He was Cornelius Gurlitt, Hildebrand's son, and he was carrying a large amount of cash, which he claimed was from the sale of an artwork in Bern. Suspecting him of tax evasion, the German police investigated his background and two years later, they discovered his father's hidden art collection containing more than 1,500 works. So far, only a few of them have been proved to have been looted, but investigations continue.

The Ghent Altarpiece

One of the world's greatest masterpieces, the Ghent Altarpiece is a huge polyptych — or a painting consisting of more than three leaves or panels joined by hinges or folds.

Also known as the *Adoration of the Mystic Lamb*, it has 12 panels and was painted from around 1420 to 1432 by the brothers Hubert (c. 1385/90–1426) and Jan van Eyck (c. before 1390–1441) for the Vijd Chapel in the church of Saint John the Baptist, now called Saint Bavo's Cathedral, in Ghent, Belgium. The colourful and complex artwork is also commonly regarded as the first major oil painting and 'the most stolen artwork of all time'. Filled with Catholic mysticism and Bible stories, including the 'mystic lamb' that stands on an altar and bleeds into the holy grail beneath, the Ghent Altarpiece has not only been stolen, but has almost been set on fire by rioting Calvinists, been forged, mutilated, censored, sold, hunted in the First World War, and plundered several times. One part of it has been missing since the early 1930s.

The masterpiece

Widely seen as marking the shift from the art styles of the Middle Ages to the Renaissance, the Ghent Altarpiece comprises 12 hinged panels with double sets of folding wings and paintings on both sides of these. It measures 5.2 x 3.75 m (17 ft x 12 ft 4 in) when fully opened. To create it, a preparatory layer of ground chalk and animal glue was applied to the wood, then a line drawing was made to guide the painter, then a lightly tinted but still transparent priming layer of oil was added which kept the line drawing visible. Finally, oil paints were used to render the scenes with a broad range of tones and colours to create a convincing depiction of three-dimensions. The upper part of the inner panels displays the classical arrangement known as Deësis, of God in the centre, with the Virgin Mary on the left and John the Baptist on the right. On the panels next to this are angels playing music and, on the outermost panels, the figures of Adam and Eve. The lower part of the central panel displays 14 angels surrounding the Lamb of God that stands on an altar, with blood flowing from a wound on its chest. This blood pours into a golden

OPPOSITE, TOP: Closed view of the Ghent Altarpiece, back panels.

OPPOSITE, BOTTOM: The front view of the Ghent Altarpiece, by Hubert and Jan van Eyck, c. 1420-32.

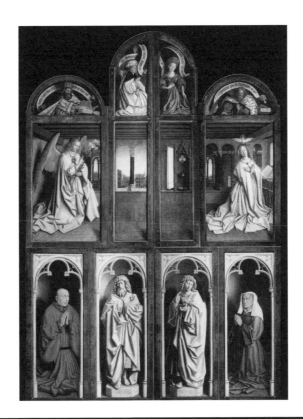

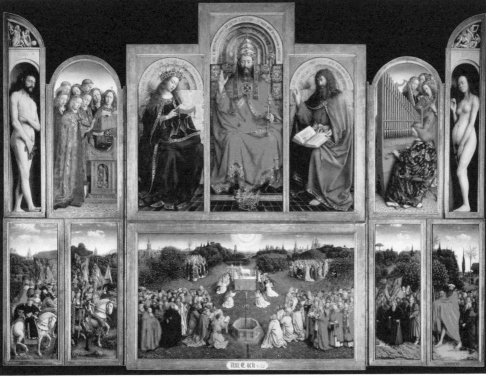

chalice, but the lamb shows no sense of pain as it looks out from the panel. As the angels worship the Lamb, some hold symbols of Christ's Passion and two hold incense-filled censers. A dove representing the Holy Spirit hovers low in the sky directly above the lamb. Beyond the angels are several other groups of figures, including saints, martyrs, clergy and hermits, plus knights and judges on horseback, all venerating the lamb. When the altar is closed, the four lower panels display 'grisaille' paintings. These are monochrome images that were created to look like works of sculpture. These feature images of Saint John the Baptist and Saint John the Evangelist as well as portraits of the two donors who commissioned the original altar, Joost Dijdt, the Mayor of Ghent at the time the altarpiece was created, and his wife Lysbette Borluut. Above is a representation of the Annunciation, where the Archangel Gabriel tells the Virgin Mary that she is to bear a son. Still further above these, the artists have painted prophets and sibyls. The entire work is rich in detail and in jewel-bright colours, achieved through the artists' innovative use of oil paint (previously, most paint in

Q PROBLEMS AND MISADVENTURES

The Ghent Altarpiece has suffered many misadventures since its inauguration. In 1566, a mob of angry Calvinists tore through Ghent, protesting against the Catholic fondness for religious statues and paintings, which they regarded as contemptible and dangerous idolatry. Although they smashed open the doors of Saint Bavo's using a tree trunk, the altarpiece was no longer there: it had been hastily disassembled and hidden in the cathedral tower. It was later restored to its original position, but a second wave of rebels tried to set fire to it ten years later and once again, the church authorities managed to dismantle and hide it in time.

In 1794, invading Napoleonic forces plundered four panels of the altarpiece and took them to Paris where they were put on display. After Napoleon was defeated at the Battle of Waterloo in 1815, the restored French king Louis XVIII returned the stolen artwork to thank the city of Ghent, which had sheltered him during his exile. However, the following year, the vicar-general of Saint Bavo's allegedly stole six of the panels and sold them to an art dealer, and they were bought from him by the King of Prussia. Whether this is the true story or not, they eventually ended up in a museum in Berlin. Concurrently, panels showing Adam and Eve were exhibited in a museum in Brussels. Next, the altarpiece was stolen by German troops during their occupation of Belgium in the First World War (1914–18), but the terms of the Treaty of Versailles that marked the end of the war included the return of the panels to Ghent. When the Brussels Museum handed back the Adam and Eve panels at the same time, it meant that the Altarpiece was whole and complete for the first time in over a hundred years.

Europe had been made with pigment mixed with egg – or tempera). Across the work, the images are created with detailed and subtle effects of light and tone, modelled through the more malleable properties of oil paint, including the use of thin, transparent layers and glaze and fine rendering of surface textures and reflections. Jan van Eyck is one of the first artists in history to have painted nature in such an exceptionally detailed and realistic way, and the work is also one of the first paintings to include depictions of craters on the moon. Before the Ghent Altarpiece, only portrait miniatures and illuminated manuscripts contained such a level of detail, and these were rarely seen by 'ordinary' people. Nothing like it had ever been attempted on such a grand scale. When the work was officially installed in the cathedral on 6 May 1432, it would have stunned onlookers, and it remains one of the most coveted paintings ever created.

It is generally accepted that most of the work was completed by Jan, after an overall design by Hubert, who probably oversaw the construction of most of the frames before he died in 1426. For most of its existence, the altarpiece remained closed throughout much of the year, only being opened on feast days to allow the inner, vividly coloured panels to be viewed by the congregation.

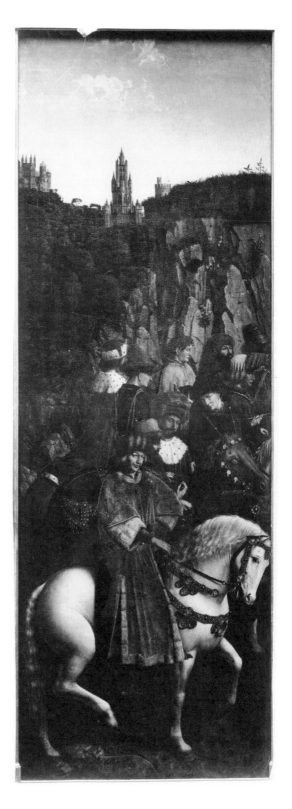

RIGHT: A black and white image of the panel the *Just Judges*, also called *The Righteous Judges*, which was stolen in 1934 and has never been found.

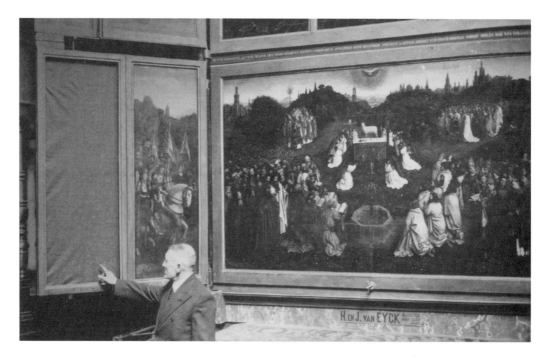

The lost judges

Fifteen years later, during the night of 10 April 1934, a panel of the altarpiece was stolen from the cathedral. On one side was the monochrome painting of Saint John the Baptist, and on the other was *The Just Judges*, a colourful and detailed portrayal of several contemporary figures, including Philip the Good, Duke of Burgundy, and possibly Hubert and Jan van Eyck themselves. The panel was removed carefully, and it was only the following morning that a church warden discovered the theft. Within hours news had leaked out into the town and beyond. Hundreds of people arrived and packed into the cathedral. All believed that they could help find the missing panel. When the police arrived, they could barely squeeze inside, yet they did not move everyone away from the scene of the crime. They took no photographs, nor fingerprints of the area, nor did they seal the premises. Instead, as the crowd continued to swell, they left the cathedral and went to investigate another robbery in a nearby cheese shop.

A fortnight later, the Bishop of Ghent received an anonymous ransom note, demanding one million Belgian francs for the panel's return. At that point, the Belgian government took over the negotiations, and in the following months, several notes were exchanged between the

TOP: The morning of the theft of the *Just Judges*.

BOTTOM: Arsène Goedertier, the self-proclaimed thief of the *Just Judges,* declared on his deathbed to his lawyer that he would never reveal where the panel was hidden.

government and the ransomer. To demonstrate sincerity, the thief returned the grisaille painting of Saint John the Baptist that had formed the back of the panel. Nothing else happened for months, and then in November, a Belgian stockbroker, Arsène Goedertier, suffered a heart attack. He was a devout Catholic, but instead of asking for a priest to administer last rites as he lay dying, he asked for his lawyer, Georges de Vos, to be summoned. After his client had died, de Vos reported that the stockbroker had whispered to him: 'I alone know where the Mystic Lamb is. The information is in the drawer on the right of my writing table, in an envelope marked "mutualité".' Some time later, De Vos did as Goerdetier had indicated and in the drawer he found an envelope, inside of which were carbon copies of all the ransom notes, plus a final note that had not been sent that read: '[It] rests in a place where neither I, nor anybody else, can take it away without arousing the attention of the public.'

De Vos's consequent actions seem puzzling. He failed to tell the police about Goedertier's dying revelation, nor did he hand over the ransom notes. Instead, he met with four fellow lawyers, including a district attorney, two presidents of the court of appeals, and Franz de Heem, the crown prosecutor who had headed up the ransom negotiations. Without informing the authorities, the five men began their own private investigation. None of them ever suffered any punishment for keeping the authorities in the dark. But it seems that all they found was a fake passport under the name Arsène van Damme and the typewriter that Goedertier had used to compose the ransom notes. Instead of keeping it as evidence, the men used it to write their own reports on their findings. They also found out that just a few days after the initial crime, Goedertier had opened a new bank account into which he had deposited 10,000 francs, plus a key, that years later, it was discovered could open the loft of Saint Bavo's Cathedral.

When, a month after the event, the police were eventually notified of Goedertier's deathbed confession, they did not even interview Georges de Vos, who had witnessed it.

The mystery is multi-layered. Goedertier was an extremely unlikely thief. He was known to have been a good Catholic and a philanthropist, who helped to run two Catholic charities, was involved with his local church and had co-founded a Christian health service. Adding to the implausibility, an eye disorder meant that he was unable to see in the dark, so it was doubtful whether he could have robbed a cathedral at night. Nor did he need the ransom money; his bank account contained a small fortune. The panel that was removed from the altarpiece was so high up off the ground and so heavy that it could not have been taken by one person alone.

So, perhaps one or more of the custodians of Saint Bavo's was involved in the theft. Or perhaps not, as it was found the day after the theft that the doors of the cathedral were open, so the thieves may have come in from outside – and they may or may not have been assisted by someone inside.

Years later, the detective who was put on the case was given access to 600 pages of archives relating to the painting, but bafflingly, papers relating to the period from 1934–45 were missing. During the Second World War, the Nazi party's chief publicist, Joseph Goebbels, instructed a specialist detective, Heinrich Köhn, to travel to Ghent

TOP: A letter from the Belgian police to Scotland Yard regarding the theft of the *Just Judges,* at the state archive in Ghent, Belgium.

BOTTOM: A drawing and notes detailing a theory relating to the theft is retained as evidence in the archived police file.

TOP: The original 1934 police report regarding the theft, with a note that reads 'Never destroy file'.

BOTTOM: An illustration showing the panel on both sides in the archived police file.

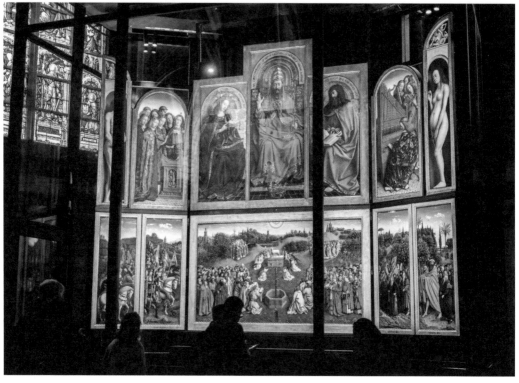

and find the Lost Judges panel, which Goebbels wanted to give as a gift to Hitler. However, Köhn returned empty-handed, having determined that the panel had originally been hidden either in or close to Saint Bavo's, but had since been moved. Since the Second World War, Saint Bavo's has been searched six times and its structure has been X-rayed to a depth of 10 m (33 ft), but no panel, nor likely hiding place has yet been found.

However, in 2018, an engineer and amateur sleuth, Gino Marchal, who had written a book on the subject co-authored by Marc de Bel, declared that he had solved the mystery. He announced that the clue to the missing panel's location was just six words and the number 152. At a press conference in Ghent City Hall, Marchal announced that the hiding place was beneath the Kalandeberg square in the centre of the city. Ghent's mayor Daniël Termont said the public prosecutor's office 'takes this theory very seriously'. He also warned residents not to start digging up the square themselves. Nonetheless, when the authorities did excavate that part of the square, nothing was found. Further investigations included searching under the floorboards of a private home and beneath a car park. The case remains open and the police regularly receive new clues and suggestions about the painting's whereabouts, but the panel itself remains missing.

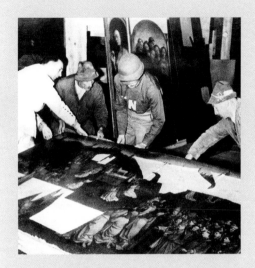

Q THE SECOND WORLD WAR

When the Second World War began in 1939, the Belgians sent the Ghent Altarpiece – without the stolen *Just Judges* panel – to south-western France for safekeeping. However, the Nazis occupied France soon after, and in 1942 they stole the work, planning for it to be the centrepiece Hitler's planned Führermuseum. They kept it at first in Neuschwanstein Castle in Bavaria, but as the war drew to an end and the Allies closed in, they moved it to Altaussee, an Austrian salt mine, where the humidity of the damp, salty atmosphere damaged it. At the end of the war, the altarpiece was recovered from its hiding place by the Monuments Men (pictured above) and restored, with the addition of a copy made of *The Just Judges*. Today, it is back in Saint Bavo's Cathedral, although not in its original position, and it is now housed within a bullet-proof display case that is 6 m (nearly 20 ft) high.

OPPOSITE, TOP: Visitors watch the restoration of the panels of the Ghent Altarpiece at the Fine Arts museum in Ghent, Belgium, in 2012.

OPPOSITE, BOTTOM: Ghent Altarpiece (The Adoration of the Mystic Lamb) in St Bavo's Cathedral, Ghent, Belgium, in 2022.

The Mask of a Faun

One of the greatest of all artists, Michelangelo di Lodovico Buonarroti Simoni (1475–1564) was also an architect and poet.

Among his most celebrated works are the marble statues of *Pietà* (1498–99) in Rome, of *David* (c. 1501–04) in Florence, the huge frescoes on the ceiling of the Sistine Chapel (1508–12) and *The Last Judgement* on the Chapel's altar (1536–41).

When he was about 15 years old, Michelangelo created one of his first works of sculpture, a marble head of a man or, as it is more commonly described, a mask of a faun. Fauns are mythical creatures, half-human and half-goat, that first appeared in Greek and Roman mythology. Originally the Greeks described them as naked men, while in Roman legends they were ghosts of the countryside. By the Renaissance, they were depicted as creatures with two legs, horns, fur and the tail of a goat, and the head, torso and arms of a man, often portrayed with pointed ears. They were believed to protect the woods and the countryside.

The Medici Garden

Michelangelo's *Mask of a Faun* was most likely based on an antique work of sculpture, but the young artist added his own individual details, including an open rather than a closed mouth, showing teeth and a tongue. According to the painter, architect and art historian Giorgio Vasari (1511–74) in his 1550 book *The Lives of the Most Excellent Painters, Sculptors, and Architects*, Lorenzo de' Medici (1449–92), the ruler of Florence and patron of the arts, saw Michelangelo's M*ask of a Faun*, with its grin and tongue, and he suggested that an old faun would not have so many teeth. Immediately, Michelangelo knocked out a tooth from the upper jaw. Impressed by the boy's speedy and creative response, Lorenzo invited him to join his sculpture garden and school at San Marco in Florence, a sort of private art academy and creative space that he had established. It was the first such art academy in Europe, where Michelangelo and other young, hand-picked students could study the Medici art collection and practise creating their own works under the supervision of the sculptor Bertoldo di Giovanni (after

OPPOSITE: Cast of the work known as *Head of a Faun*, attributed to Michelangelo, c. 1489.

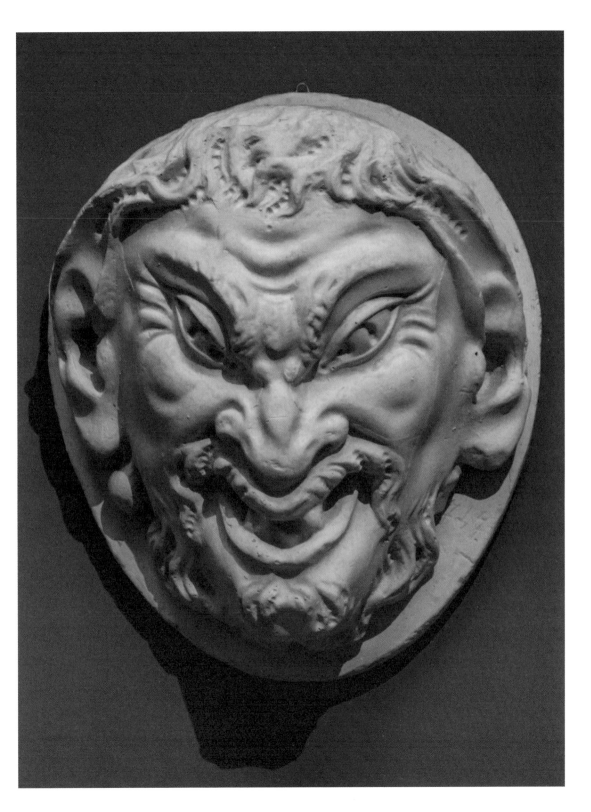

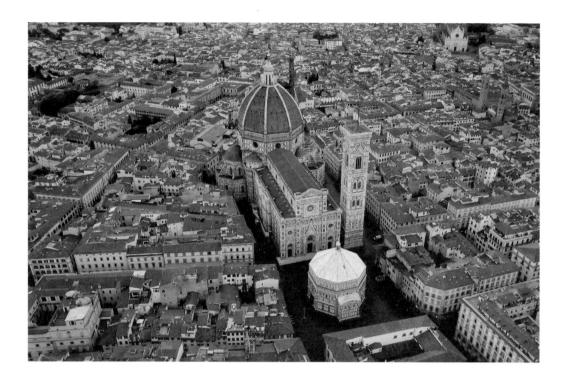

1420–91). Michelangelo attended the Medici Garden from 1489 until Lorenzo de' Medici's death in 1492.

Later history

At first, Michelangelo's *Mask of a Faun* was displayed in the Uffizi Gallery in Florence, but in 1865, was moved to the Museo Nazionale del Bargello (Bargello National Museum). After the outbreak of the Second World War in 1939, the authorities in Italy decided that its art collections needed to be moved out of the cities. So the Florentine art treasures were dispersed to several private villas and palazzos dotted around Tuscany. The Bargello's sculptures, among them Michelangelo's *Mask*, were sent in December 1942 to the Castello di Poppi (or Palazzo Pretorio) in the Tuscan village of Poppi, which was also the destination chosen for the safekeeping of paintings from Florence's principal art galleries. Then, between 22 and 23 August 1944, German soldiers plundered the castle and seized nearly all the art being kept there. The soldiers loaded all the artworks onto trucks, with Michelangelo's *Mask of a Faun* probably being put on the tenth truck of many, which paused for some days in Forlì, northern Italy, and then left there on 31 August. The Castle of Poppi was left damaged and dirty, its walls broken and doors smashed. In an attempt to justify the crimes, two German soldiers explained that the looting was 'by order of the German High Command, that it was

only to save the works of art from being taken away by the Anglo-American troops, that the High Command was extremely sorry that it had to leave so many pictures there, and that all trace of the episode must at once be removed, even to the point of walling up the doors again'. On the day that they had robbed the castle, German troops also discharged several mines around the town. The damage caused was widespread, rendering the medieval gate and some local homes into ruins, and destroying the only road in and out of Poppi.

By September, after three weeks of trying to reach the area, Italian investigators discovered that in total, 198 works had been taken, including works by Rembrandt, Raphael, Rubens, Lucas Cranach the Elder, Pieter Brueghel the Elder (c. 1525/30–69), Jean-Auguste-Dominique Ingres (1780–1867) and Filippo Lippi (c. 1406–69).

There are no further references to Michelangelo's *Mask of a Faun* and no trace of it has ever been found.

OPPOSITE, TOP: Cityscape of the main square in Forli, northern Italy, where the convey of looted artworks stopped for several days.

OPPOSITE, BOTTOM: The loggia on the first floor of the National Museum of Bargello in Florence, Italy.

🔍 MICHELANGELO

Sculptor, painter, architect and poet, Michelangelo Buonarroti (self-portrait pictured left) was the first artist to be recognised by his contemporaries as a genius. Born in Caprese, a village in Tuscany, Italy, he trained in Florence, first as a painter with Domenico Ghirlandaio (1448–94) and then as a sculptor under the patronage of Lorenzo de' Medici. In 1496, he went to Rome and there he created the sculpture *Pietà* when he was just twenty-three years old. Back in Florence five years later, he sculpted *David*, a huge marble statue of the biblical hero, using a figure with whom the city identified. Then, in 1505, he was summoned to Rome once again to begin work on a marble tomb for Pope Julius II. From 1508 to 1512, he painted the Sistine Chapel ceiling with scenes from the Old Testament. Known for his hot temper as much as his genius, Michelangelo came to be called Il Divino, or The Divine One, and achieved great renown in his own lifetime for his art.

Lost Caravaggio

Adjacent to the church of San Francesco d'Assisi in Palermo, Sicily, is the Oratorio di San Lorenzo, built in 1569 to replace a former smaller church dedicated to St Lawrence (San Lorenzo).

From 1699–1706, local sculptor Giacomo Serpotta (1656–1732) created a lavish, gleaming white stucco interior for the oratory, depicting the life of St Francis of Assisi (San Francesco d'Assisi), and until 1969, it also contained *The Nativity with St Francis and St Lawrence* by the Baroque artist Caravaggio (1571–1610). Milan-born Caravaggio lived and worked predominantly in Rome, but in 1609 he was in Palermo briefly, hoping for a papal pardon after he had murdered a man. *The Nativity with St Francis and St Lawrence*, also sometimes called *The Adoration*, was one of four prestigious and lucrative commissions Caravaggio received while staying there. From the time that he completed it, 50 years after the oratory was built and 90 years before Serpotta added his opulent decorations, the large canvas – of almost 6 square metres (64.5 square feet) – was displayed permanently above the oratory altar.

In accordance with his normal style, Caravaggio abandoned traditional compositions and methods of oil painting in favour of original ideas. In rich, dark colours, the painting depicts the Christ Child lying on a white cloth on the floor, while his mother, a somewhat dishevelled Virgin Mary, sits close by on a low seat, watching her baby. It is a natural scene; the baby and mother hold each other's gaze. The other holy figures crowd closely around, looking similarly peasant-like, while above, a foreshortened angel holds out a scroll inscribed 'Gloria in Excelsis Deo' ('Glory to God in the Highest'). Caravaggio was famed for his dramatic use of chiaroscuro, or strongly contrasting shadows and highlights, and here, darkness surrounds them as light touches only parts of the main subjects, creating a sense of intimacy and inviting the viewer to look more closely.

Audacious theft

Almost four centuries after Caravaggio produced the painting, on the night of 17 October 1969, it was stolen. At least two people broke

OPPOSITE: *The Nativity with St Francis and St Lawrence*, painted by Caravaggio in 1609, stolen in 1969 and still missing.

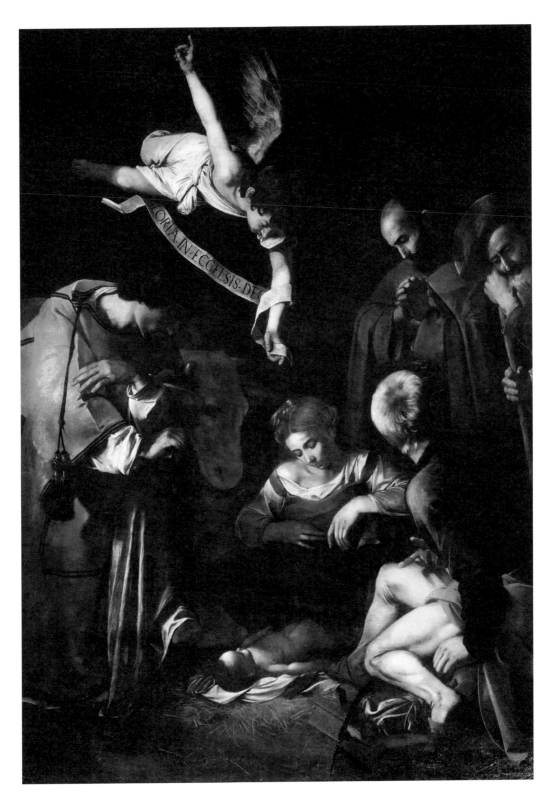

into the Franciscan oratory in the dark. Using razor blades, they cut the huge canvas from its frame above the altar. They rolled it up, wrapped it in a carpet – and disappeared. It has not been seen since. Earlier that year, the Italian government had established what was the world's first dedicated art police force. The Tutela del Patrimonio Culturale (TPC), or The Division for the Protection of Cultural Heritage, has since become the world's most effective art crime squad. However, Caravaggio's *Nativity*, widely believed to be the most valuable missing work of art in the world, remains unlocated and its theft is included on the FBI's list of Top Ten Art Crimes.

A few weeks before the theft, *The Nativity with St Francis and St Lawrence* had appeared in an Italian television programme, where it was made clear that the chapel was guarded loosely by one elderly caretaker, and this may have prompted the robbery. Speculation and rumour followed the theft, and theories differ about whether the thieves were amateurs or professionals, but investigators generally agreed that the Cosa Nostra, the Sicilian Mafia, was involved. Italian police, INTERPOL, the FBI and the TPC have all tried to locate the painting, but so far with no success. In the decades since the theft, several Mafia informants have come forward with information, all of it conflicting. Some sources said that it was so badly damaged after

ABOVE: *The Nativity with St Francis and St Lawrence*, where it used to hang in the Oratorio di San Lorenzo, Palermo before it was stolen in 1969.

the thieves removed it that it was disposed of; others claimed that it had been fed to pigs to avoid discovery. One informant recalled seeing it being used as a floor mat by the Mafia boss Salvatore Riina, while another said that Riina still had it and showed it off during meetings.

The Mafia

In 2001, the parish priest of the Oratory of San Lorenzo, Monsignor Benedetto Rocco, who died in 2013, astonishingly revealed that the Sicilian mafia boss Gaetano Badalamenti had the painting, and had tried to extort the church for its return. Rocco said: 'A few months after [the theft], a letter arrived at my home. In it, the thieves declared: "We have the painting. If you want to make a deal, you have to submit this advert in the *Giornale di Sicilia* [Sicily's daily newspaper]."' The advertisement would tell Cosa Nostra that the Church wanted to talk.

A fortnight later, Rocco received a second letter. He described what had happened: 'The letter was accompanied by a piece of the painting, a tiny piece of the canvas, which was intended to make clear to me that they really had the Caravaggio in their possession. I went straight to the superintendent and informed him of what was happening. I left him the letter and the piece of canvas.'

ABOVE: Salvatore Riina, chief of the Sicilian Mafia, who allegedly had the stolen Caravaggio masterpiece.

Q CARAVAGGIO – TEMPESTUOUS AND INFLUENTIAL

The passionate paintings of Caravaggio (portrait pictured right) reflect a turbulent life. Quarrelsome and quick to anger, he was often in trouble with the law and implicated in multiple murders. In his art, he challenged and changed traditions, painting pioneering images, exploiting dramatic compositions and lighting and using the poor as models for his unidealized sacred figures. Working from life without preparatory sketches, he used extreme contrasts of light and dark to focus attention on aspects of his canvases. This approach was widely imitated, and even though Caravaggio died at just 38, his influence on his contemporaries and later artists, such as the 19th-century Realists was profound. Although his poverty-stricken, dirty figures adhered to Church teachings, he was widely criticised for not making them more idealistic and wealthy looking. We know of fewer than 100 paintings by him, making the loss of his *Nativity* a particular tragedy.

Although this letter asked for a second advertisement be placed in the *Giornale di Sicilia*, the superintendent refused to co-operate further and instead launched an investigation into Rocco, on the grounds he may have masterminded the theft himself. It was only some time later that the superintendent relented, and apologised. Then, around a year after the theft, a priest in Carini, 19 kilometres (12 miles) from Palermo, telephoned Rocco with the news that he had seen a photograph of the missing Caravaggio.

In the late 1990s, an informant, or *pentito*, Salvatore Cancemi, told government prosecutors that he had seen the *Nativity* painting at meetings of top Mafia bosses in Sicily, for whom it was a symbol of their power. Badalamenti was at the time one of the dominant mafia figures in Sicily, running a vast heroin smuggling network. He was arrested in 1984 and died of a heart attack in an Italian government safe house in 2011.

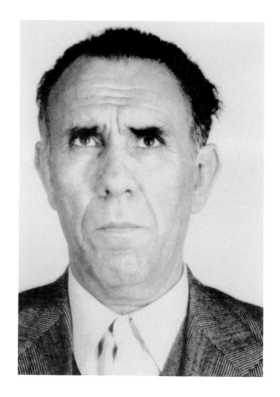

In 1993, another former Mafia member, Francesco Marino Mannoia, told investigators of his involvement in the burglary, and that he had been commissioned to steal the painting. However, when the private buyer saw the damage, he burst into tears and refused it. With not much evidence to go on, investigators decided that Mannoia's account related to a totally different painting. Instead, they conjectured that the robbery may have been carried out by amateurs, with the Mafia learning of it later on, and intervening to take the painting then. Another informant said that it was moved between Mafia bosses, and one of these, Gerlando Alberti, was trying to sell it, just as he was arrested in 1981. So instead, he is believed to have buried the painting, along with a hoard of drugs and banknotes, but later, when his nephew took prosecutors to the supposed site, the painting was not there.

In 2009, yet another informant, Gaspare Spatuzza, recalled that when he was in prison with Mafia member Filippo Graviano a decade earlier, Graviano had told him that the painting had been destroyed some time in the 1980s. According to Graviano's account, the Carravaggio had been concealed in a barn by the Pullara family, to whom the Mafia had entrusted it. It was not a good hiding place, as the painting was slowly gnawed away by rats and pits and, totally

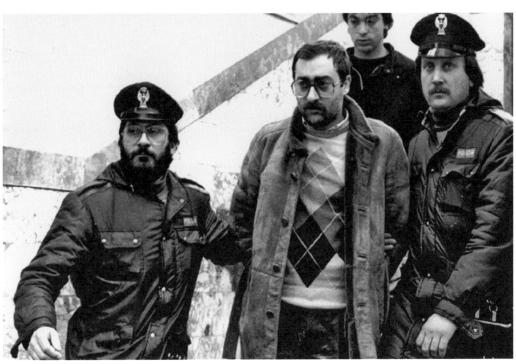

ruined as a result, the canvas was burnt. In 2018, another *pentito*, Gaetano Grado, claimed that he had information about the missing *Nativity*. He told investigators that the theft had been carried out by amateurs, and that the Mafia had secured it from them. Eventually, the valuable painting ended up in the possession of the Mafia boss Gaetano Badalamenti, who sold it on to a Swiss art dealer. Allegedly, it was cut into pieces to hide it when it was taken out of Sicily. The named Swiss dealer has since died and the painting was not found in his collection, nor any evidence that it ever passed through his hands. Others have asserted that the painting ended up in eastern Europe or South Africa, where it was sold to an art collector, or that it was about to be sold on the black market, but was then destroyed during the earthquake that hit Irpinia in southern Italy in 1980. Not one of these stories or leads has been substantiated nor resulted in the painting's discovery. While the Caravaggio *Nativity* is missing however, hope remains that it still exists.

OPPOSITE, TOP: Gaspare Spatuzza heard tales of the painting's whereabouts in prison. He eventually became one of the leaders of the Sicilian Mafia after Filippo Graviano.

OPPOSITE, BOTTOM: Survivors after the 1980 Irpinia earthquake, in which the *Nativity* was supposedly destroyed.

ℚ TUTELA DEL PATRIMONIO CULTURALE (TPC)

On 3 May 1969, Il Nucleo Tutela Patrimonio Artistico was founded as the first specialist art and artefact recovery police force in the world. In March 1992, the force was renamed Comando Carabinieri per la Tutela del Patrimonio Culturale (National Police Command for the Protection of Cultural Heritage). Comprising four sections: archaeology, antique dealing, fakes and contemporary art, the TPC is based in Rome with 12 regional offices. It investigates unauthorised excavations, the theft and illegal trade involving works of art, damage to monuments and archaeological sites, and the unlawful export of cultural property and fake artworks. The force is involved in the management of archaeological sites, the activities of art and antique dealers and restorers, forensic analysis, advising overseas ministries, international peacekeeping missions, and the protection and recovery of cultural property in disaster zones. It works internationally with other organisations including UNESCO and INTERPOL, and at home, it collaborates with universities, cultural foundations, research centres and churches. Pictured below is a volunteer in the UNESCO-TPC joint venture looking at a Madonna with child painting in the seriously damaged church of San Francesco in the village of Visso after an earthquake in 2017.

Labour Day Looting

Shortly after midnight on the morning of Labour Day, 4 September 1972, a big public holiday in Canada, three men broke into Montreal Museum of Fine Arts.

The ensuing heist is sometimes called 'the Skylight Caper', as the three criminals – wearing ski masks – climbed telephone poles and a tree next to the museum and on to the roof, then they opened an unsecured skylight where the alarm was deactivated because it was awaiting repair. They climbed through, and using a nylon rope, they descended into the building. When one of the three security guards on duty, unaware of the intruders, walked nearby to make a cup of tea, one of the men fired a gun up to the ceiling. Turning, the guard was overwhelmed by the robbers and forced to the floor. The two other guards ran to see what was causing the noise, and before long the robbers had them bound and gagged, too. All three were led off and held together in a lecture hall. While one of the thieves stood watch over them, his two accomplices spent half an hour stealing 18 paintings and 39 figurines and pieces of jewellery. Once they had helped themselves to what they wanted, the thieves tried to escape through the skylight using a system of makeshift pulleys, but this took too much time, so instead they used one of the guard's keys to escape through the garage. However, when they left with their first load, one of the thieves triggered the side door's alarm. So, panicked, the men stuffed the jewellery into their pockets and made off with only half of the paintings, running out of the back door and fleeing down the road.

First space for art

By 1972, due to various political, social and economic changes, the Montreal Museum of Fine Arts (MMFA) – founded as the Art Association of Montreal in 1860 and the first space in Canada created solely for the exhibition of art – was facing financial difficulties and needed to reduce its outgoings. It changed from being a private institution to a semi-public non-profit organisation, and many discussions ensued over how it could be refurbished to meet the requirements of the late 20th century. After much deliberation,

OPPOSITE, TOP: Exterior of the Montreal Museum of Fine Arts (MMFA) in Quebec.

OPPOSITE, BOTTOM: View of the interior of the Montreal Museum of Fine Arts.

OVERLEAF: A selection of the stolen works.

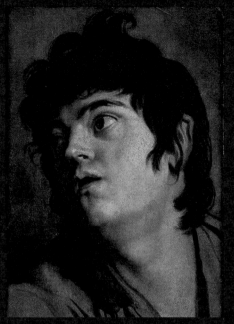

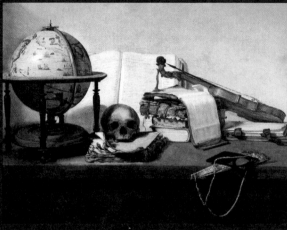

Vanitas Still Life with Books, a Globe, a Skull, a Violin and a Fan, Jan Davidszoon de Heem, c. 1650

Head of a Young Man, Peter Paul Rubens, c. 1601–02

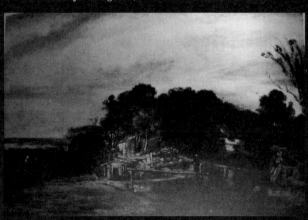

Landscape with Cottages, Rembrandt van Rijn, 1654

The Sorceress, Narcisse Virgilio Díaz, 1851

The Banks of a Stream, Gustave Courbet, 1873

Path Through A Village, Aegidius Sadeler II

La Reveuse à La Fontaine (Dreamer at the Fountain),
Jean-Baptiste-Camille Corot, c. 1855–63

Landscape with Rocks and Streams, Gustave Courbet, 1872

those in charge decided that the museum would close in 1973 for a three-year renovation project.

In the period leading up to the closure, security in some areas of the building was not as stringent as it had been, and the thieves took advantage of this. The alarm which sounded as they escaped through one of the museum's side entrances, meant they left several of the items they had intended to take and fled with a slightly lighter load. Meanwhile inside the museum, the guards were struggling to free themselves and, eventually, an hour after the robbery ended, one managed it. At around 3am, he called the police. Unfortunately, the security guards were unable to provide much information as the intruders had been masked. They did note however, that two spoke French and one English. News of the robbery and the names of the stolen works were printed in newspapers across North America. Investigators went into action immediately, contacting INTERPOL, the Art Dealers Association and the International Art Registry. The Montreal police issued a notice to border checkpoints, putting customs officials on alert to keep an eye open for the stolen artworks, but there were no further clues or sightings. It was deduced that the robbers had known exactly what they wanted. Many of the stolen works had only recently been on display in a travelling exhibition called *Masterpieces from Montreal*, which had been shown in museums across the United States and Canada, so it could have been that the thieves were either commissioned to steal by someone who had seen the works at the exhibition, or that they themselves had done so.

ABOVE: Director of Public Relations for MMFA, Bill Bantey.

Stealing history

Although the stolen works were exceptionally valuable, none of them was large, so it is possible that they were taken to be sold on to private individuals for display in their homes. They included many unique paintings. *Landscape with Cottages* (1654) by Rembrandt van Rijn, was an atmospheric painting of cottages surrounded by shadowy trees beneath an overcast evening sky. Rembrandt's landscapes contrast dramatically with other Dutch landscapes of the period. While the popular style was smooth and light-filled, Rembrandt's features thick paint and a dark palette. It was probably

the most valuable work of the heist. Also taken was *Lioness and Lion in a Cave* (1856), an expressive, freely painted depiction by Eugène Delacroix (1798–1863). Fascinated by the exotic, Delacroix often painted hunting scenes and animals, even though it was unlikely that he had ever seen genuine wild animals in their natural habitat. Instead, he made detailed studies of animals in zoos and of landscapes on his travels in north Africa. One of the greatest painters of still lifes in the Netherlands, Jan Davidszoon de Heem (c. 1606–84), produced meticulous still lifes and vanitas paintings. The heist included his *Vanitas Still Life with Books, a Globe, a Skull, a Violin and a Fan*, of c. 1650, which suggested the vanity of earthly possessions. *Landscape with Buildings and Wagon* by Jan Breughel the Elder (1568–1625) was an innovative landscape by the Flemish painter and draughtsman who worked in many genres, including history paintings, flower still lifes, allegorical and mythological scenes, landscapes and seascapes, village and battle scenes. Two figure paintings by Jean-Baptiste-Camille Corot (1796–1875) were also taken. *La Reveuse à la Fontaine*, c. 1855-63 and *Jeune Fille Accoudée sur le Bras Gauche*, 1865 are two of Corot's accomplished and emotive works that contrast with the landscapes he was more generally known for. *Landscape with Rocks and Stream* of 1873 by Gustave Courbet (1819–77), was created with thick flecks and slabs of paint, following his objective, Realist style that rejected academic convention. Finally, *La Baratteuse (Young Woman Churning)* of c. 1849–50, by Jean-François Millet (1814–75) characteristically depicts the hard life of a peasant, although the young woman was portrayed as a young woman of the nobility would usually have been. For his style and bold approach, Millet became hugely influential on Vincent van Gogh.

ABOVE: Newspaper coverage of the story of the heist at the time.

Negotiations

Meanwhile, a few days after the theft, an anonymous caller instructed a member of the MMFA's staff to go to a nearby public telephone booth. As instructed, the museum director walked to the specified booth, and answered the ringing phone. A voice told him to pick up a cigarette packet that had been left nearby. Inside was a pendant from the haul. This suggested that the thieves might be

Despite huge publicity and concerted efforts, no more of the works have been recovered and negotiations have ceased. At the time the theft occurred, it did not receive the attention it should have done. Over that particular Labour Day weekend, it was just one of several major news stories. Two days earlier, on 2 September, the Canadian hockey team (pictured left) had lost an important game against the Soviet Union, which was a crushing blow nationally. By the morning of 5 September, most of the world's attention was focused on the hostage crisis at the Munich Olympics. So, for more than half a century, the trail has been cold. None of the thieves has either been identified or arrested and the cache of important works of art remain missing.

open to negotiations to return the art. For several weeks, further phone calls and letters passed between the anonymous thieves and the museum. One day, a brown envelope arrived at the museum containing snapshots of the stolen paintings. From then, even the cautious museum directors began negotiating. At first, the thieves asked for $500,000 (£40,000) for the return of the art, then soon after, they halved their demand. The negotiations continued for years with no significant movement. When the museum demanded more proof that they had the paintings, they received instructions that the museum's security director should go to a locker in Montreal Central Station. When he did so, secreted inside the locker he found *Landscape with Vehicles and Cattle*, (date unknown), by a student of Jan Brueghel the Elder (1568–1625).

LEFT: New reporter Bob Beneditti on the ladder left behind by the art thieves.

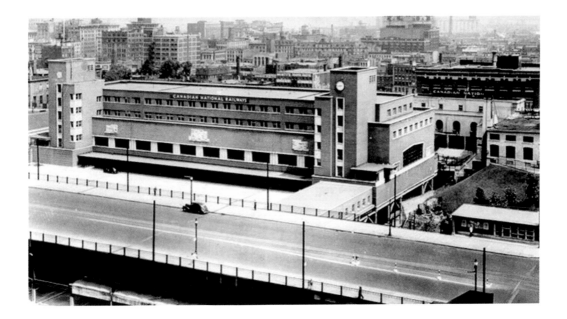

Only this painting and the pendant have been recovered from the heist, despite several unsuccessful negotiations. At the time they were taken, the stolen artworks were valued at around US $2 million, currently, they are estimated to be worth approximately $20 million. It was the largest art theft in Canadian history.

Inside job ruled out

Soon after the heist, investigators considered the possibility that it had been an inside job. The thieves apparently knew that the alarm was not working on the skylight and so it seemed possible that someone from within the museum might have helped them. However, a thorough probe of the workers involved with the skylight ruled this out. It was likely that the robbers had learned of the skylight flaw simply through investigation. A couple of weeks before the theft, it had been reported that two men wearing sunglasses, strangers to the museum, were seen sitting on chairs on the roof, and smoking. When questioned, they said they worked at the museum, but this was later found to be untrue. The theory that the heist had been an inside job was also weakened by the way the thieves' messed up their escape. After they tried leaving by the same skylight, they next tried to escape in one of the museum's trucks. Had they been employees of the museum, they would have known how to disable the alarm which went off as they left

CHAPTER 6

Friends Disunited

Although Francis Bacon (1909–92) was more
than ten years older than Lucian Freud (1922–
2011), when they met in 1944 in London, they
immediately struck up a friendship that lasted
for over 20 years.

From the time they met, they became virtually inseparable, seeing
each other almost every day. Freud's second wife, Lady Caroline
Blackwood, later recalled that she saw Bacon for dinner 'nearly every
night for more or less the whole of my marriage to Lucian. We also
had lunch'. Freud's marriage lasted for six years, but the friendship
between the two artists continued for two-and-a-half decades. With
their respect, rivalry, and both common and contrasting opinions,
they fuelled each other's creativity.

During the 1950s and 1960s, the two men spent much time
together in the bohemian parts of Soho: in the Gargoyle Club, later
the Colony Rooms, the French House and the Coach & Horses. There
they mixed with other artists including Frank Auerbach (b. 1931), and
writers and poets including Simone de Beauvoir (1908–86), Jean-Paul
Sartre (1905– 80) and Stephen Spender (1909–95). Throughout their
time together, the two men chatted, argued, drank, discussed and
shared ideas, and they examined and appraised each other's work,
advising on and criticising what they saw. Although they both
painted in a figurative tradition at a time when abstract art was
popular, neither of their styles nor methods remotely resembled the
other's. For example, at Freud's first sitting for a portrait by Bacon in
1951, he was intrigued by Bacon's rapid and instinctive method of
working, as Bacon sought to capture the essence of Freud's
personality rather than attempt to capture a direct physical
imitation. In contrast, when Bacon sat for Freud, he was shocked at
the time it took Freud to paint. For his portrait by Freud, Bacon sat
on many occasions over a three-month period, as Freud
painstakingly sketched, painted, wiped and repainted, in order to
achieve his own psychological insight into his friend. Freud once
reflected: 'I realised immediately that [Bacon's] work related to how
he felt about life. Mine on the other hand seemed very laboured.
That was because there was a terrific amount of labour for me to do

OPPOSITE: *Portrait of
Francis Bacon* by Lucian
Freud, 1952.

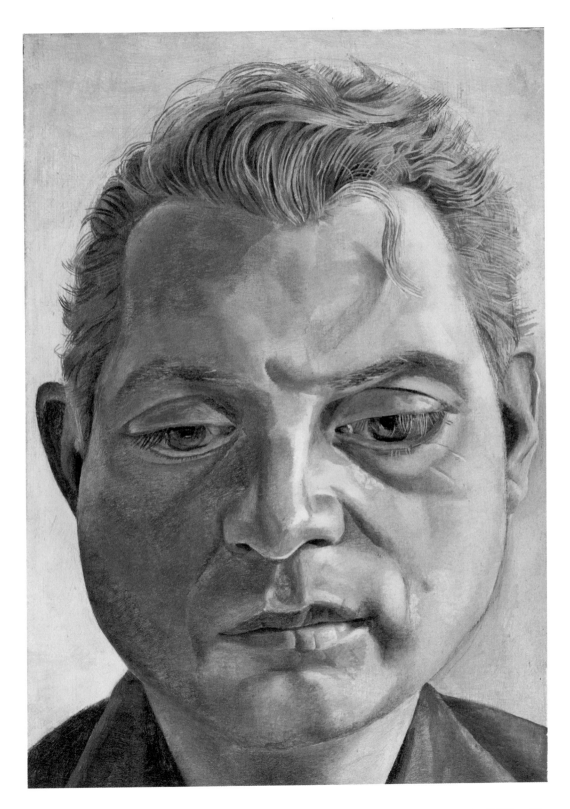

anything – and still is. Francis on the other hand, would have ideas, which he put down and then destroy and then quickly put down again. It was his attitude that I admired. The way he was completely ruthless about his own work. I think that Francis's way of painting freely helped me feel more daring.' Comparisons have often been made between Freud's approach to painting and the working methods of his grandfather, Sigmund Freud, the famous Austrian. neurologist and founder of psychoanalysis.

The two portraits

Created in 1952, Freud's intimate portrait of Bacon is small and smoothly painted. The face fills the canvas; there is no background, no gestures or flourishes of paint. Tonal contrasts are strong, with the light falling on the right hand side of the face. The thin layers of paint have been applied carefully with small brushes as Freud clearly considered every placement of mark and every angle of brush. Bacon does not look out from the canvas, but lowers his gaze. His thoughts are inscrutable. A small lock of hair falls on his forehead, his mouth twists to create an enigmatic expression. It might be that he was disgruntled, or eating, or speaking or pondering. The sense of ambiguity puts power into this tiny canvas.

In strong contrast, Bacon's triptych of Freud: *Three Studies of Lucian Freud* (1969) is life-sized and portrayed in a palette of vibrant yellows. In each image, Freud wears a white shirt with the sleeves rolled up. His hands are in his lap, the soles of his shoes turn up to face the viewer and his dark blue sock can be seen. He sits in a cane chair and there is also a headboard in the background that adds to

BELOW, LEFT: Francis Bacon, c. 1967.

BELOW, RIGHT: Lucian Freud in 1958.

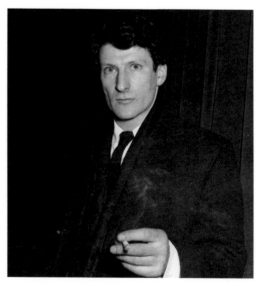

the drama of each composition. Unlike the small detailed face of Bacon painted by Freud, this large work by Bacon of Freud seems full of energy. Brushstrokes sweep over the canvases, conveying dynamism and the speed with which Bacon worked. Some areas of paint are thin, some are in thick impasto. The strong distinctions between each artist's practices influenced the other. Overall, the two works convey the powerful and energetic dialogue between the two men. When Freud painted Bacon, their friendship was strong, and by the time Bacon painted Freud, the relationship was at its height. Over the following few years however, the rapport between them waned.

ABOVE: Bacon, Freud and their friends, Timothy Behrens, Frank Auerbach and Michael Andrews having lunch at Wheelers Restaurant in Soho, London, 1963.

The fall out

It is not known why, but the strong friendship between Freud and Bacon ceased at the end of the 1960s. About 25 years after they met, they fell out, as quickly and suddenly as they had become friends. Their close bond simply seemed to dissolve. The falling out occurred soon after Bacon painted a large triptych of Freud in 1969. Just after it was completed, they either drifted apart or argued. The rift was possibly caused by Bacon's dislike of Freud's wealth and what he perceived as his snobbery, or over Freud's jealousy of Bacon's success, as Freud only became internationally famous after 1987. Another incident aggravated the ill-feeling between them. Freud owned one

🔍 COMPLETED PORTRAITS

During the 1960s, the two artists' friendship was at its most intense. By then, Bacon was attracting a great deal of international attention after some significant exhibitions of his work, and his relationship with his partner George Dyer was going well. Over the course of these years, Bacon produced 16 portraits or studies for portraits of Freud. Portraiture became Freud's main subject, and from the 1950s, he made several drawings of Bacon, but his slower working methods meant that the subsequent paintings usually remained unfinished (pictured above is one of Freud's sketches). He actually completed only one portrait of Bacon, the small oil painting on copper in 1952, measuring 18 x 13 cm (7 x 5 in) and which was later stolen as described here.

of Bacon's paintings – not a portrait of either of them – but he would not lend it to the Tate when Bacon asked him to do so for an exhibition. Although they respected each other, neither artist admired the other's work, and they were both volatile, so it is perhaps surprising that they remained such close friends for as long as they did.

The theft

In 1988, Freud's 1952 portrait of Bacon was stolen from the Neue Nationalgalerie in Berlin while it was on loan there from London's Tate Gallery for an exhibition. An official photographer had gone into the gallery to take photos of the exhibition at around 11.30am that morning. Four hours later, at 3pm, the theft was finally reported by a security guard. Belatedly, the museum was shut and all the visitors at the time were searched and questioned before being allowed to leave, but nothing was found. One visitor observed that the painting had not been on the wall soon after midday. On that day, only one of the usual three guards had been posted in the part of the gallery where the painting was displayed, and he had not seen anything unusual. As the work was so small, it could have easily been hidden away as it was stolen. The film from CCTV cameras was scrutinised, but the theft had not been recorded. Although 25,000 Deutschmarks ($14,000/£11,000) was offered for any information that would lead to the retrieval of the painting, its whereabouts remained a mystery.

Ransom demand

A year after the painting's disappearance, Bacon allegedly received a ransom demand. One of his friends later explained that Bacon had received a phone call from 'a tough-sounding East End man, probably an associate of the Krays'. During the 1960s,

Bacon mixed with various East End gangsters, including Ronnie Kray. His friend, Barry Joule said that Bacon was told: 'If you want to get yer face picture back, get £100K together and wait by the phone for a call at noon exactly.'

Bacon appeared panicked, quickly stuffed £140,000 ($175,000) into a satchel, then, 'sweating and nervous,' he jumped into Joule's car. The two men disagreed over whether to contact the police. Bacon was adamant he would not do that as he was still angry about a drugs bust in 1968 that had involved his then lover, George Dyer. So instead, he relayed to the head of security at the Tate gallery what had happened, and then went home. There he waited for the promised phone call, but it never came. Several hours later, Joule and Bacon left the studio and later said that they saw 'three undercover policemen' in a Ford Fiesta. Allegedly, they all had their 'heads buried in newspapers'. Anxious that the gangsters might have seen the policemen, Bacon shouted at them in a rage. For weeks, he was convinced that the Krays and associates would be 'out to get me for grassing to the police'.

ABOVE: Wanted poster of the *Portrait of Francis Bacon*, Lucian Freud, 2001.

Berlin

In 2001, as Freud wanted to include the missing portrait in a retrospective exhibition the following year, he designed a 'wanted' poster for it, offering 300,000 Deutschmarks ($165,000/£132,000) for its safe return. He printed approximately 2,500 copies and pasted them on to billboards around Berlin. He then tried to appeal to the thief's conscience, announcing 'Would the person who holds the painting kindly consider allowing me to show it in my exhibition next June?' The poster itself is now valuable. Nicholas Serota who was the director of Tate from 1988 to 2017, called the stolen work 'the most important portrait of the 20th century'. It remains missing to this day.

The Height of Heists

The largest art theft ever to have happened in history occurred overnight on Saint Patrick's Day, 18 March 1990, in Boston, USA.

Late that night, in the city's Palace Road, some young people had just left a college party and were messing about, a little the worse for drink. One of the boys pulled a female friend on to his back and wobbled along the road piggyback style, until she tapped him on the shoulder to warn him that a couple of policemen were watching them from a nearby car. The policemen could not be seen clearly through the misty air, and the students wondered why they were there, but as the boy was under the legal drinking age, they decided to move off quickly. They ran to a friend's car parked on the same street and drove off. For a short time, the road was silent. Then, soon after 1am, the two men in police uniforms got out of their car, approached the staff entrance of the Isabella Stewart Gardner Museum, and pressed the buzzer.

Ransack

On that misty Boston March night in 1990, one of the two security guards on duty at the Gardner Museum answered the buzzer at the staff entrance. He was faced with two policemen who claimed that there had been a disturbance and that they had been sent to investigate. Without checking this claim and contravening the museum's protocol, the security guard simply opened the door and let them in. They asked him to step away from the desk, and once again, he broke protocol and did as they asked. Within minutes, the two policemen revealed themselves to be fakes and led both him and the other guard on duty that night down at gunpoint to the museum's basement, where they were both tied up and gagged. The thieves then proceeded to steal 13 important works of art.

They first attempted to remove some large paintings by Rembrandt, but a motion detector sent out a piercing shriek. This threw the thieves until one of them kicked it silent, and they proceeded to remove Rembrandt's 1633 painting, *The Storm on the Sea of Galilee*. It was the artist's only known seascape and a dramatic representation of a Bible story in which Jesus and his apostles fought

OPPOSITE, ABOVE AND BELOW: Inside the Isabella Stewart Gardner Museum, showing the empty frames from which the artworks were stolen.

OVERLEAF: A selection of the stolen works.

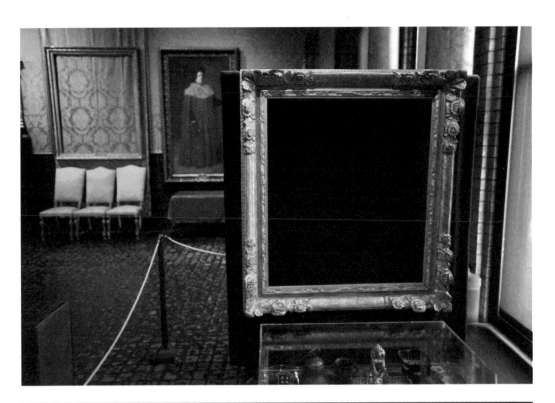

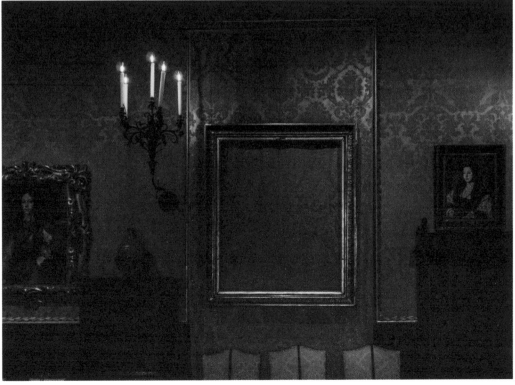

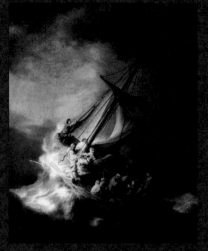

The Storm on the Sea of Galilee,
Rembrandt van Rijn, 1633

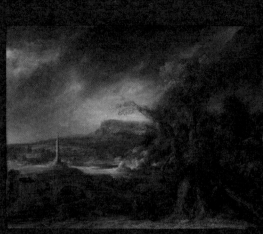

Landscape With Obelisk, Govert Flinck, 1638

One of two studies for 'an artistic soiree', Edgar Degas, 1884

Chez Tortoni, Édouard Manet, c. 1875

An ancient Chinese Gu, 1200–1100 BCE

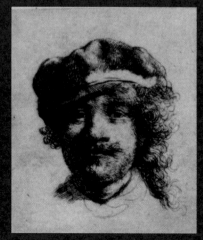

Portrait of the Artist as a Young Man,
Rembrandt van Rijn, 1633

Cortège sur une Route aux Environs de Florence,
Edgar Degas, 1850s

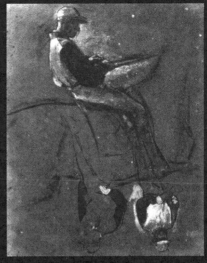

Three Mounted Jockeys, Edgar Degas, 1885-88

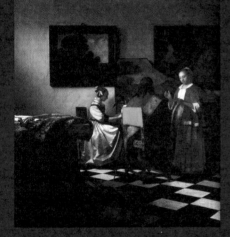

The Concert, Johannes Vermeer, c. 1664

Leaving the Paddock, Edgar Degas, 19th century

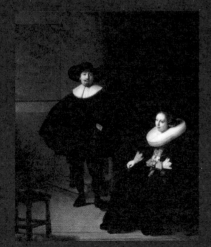

A Lady and Gentleman in Black,
Rembrandt van Rijn, 1633

a violent thunderstorm in a small boat. The thieves did not take the frame, however, but sliced the valuable canvas from its stretcher. Next, they cut another Rembrandt from its frame, a work from the same year, known as *A Lady and Gentleman in Black*. Bits of flaking canvas and paint fell to the floor as they grabbed the precious items. On a small table nearby was *The Concert* (c. 1664), a painting by Vermeer, which the men simply lifted from its stand. It is one of only 36 paintings verified as being by the artist.

As the robbers' confidence grew, fuelled by the ease with which they found they could steal the art, they became frenzied. They took another work by Rembrandt – a tiny self-portrait; *Landscape with Obelisk* by Govert Flinck (1615–60), painted in 1638; and a bronze Chinese beaker from the Shang era, dating back to 1200 BCE. It seems that they did not know what they were taking, as they ignored paintings by Giovanni Bellini (1430–1516), Raphael and Rubens, but continued to grab artworks of lower values, including five sketches

Q ISABELLA STEWART GARDNER

Isabella Stewart Gardner (1840–1924) was a doyen of the arts scene in her native New York: collector, patron and philanthropist. From wealthy family, she received a good education in New York and Europe, and after her marriage, she and her husband travelled extensively throughout Europe, the Middle East and Asia. Together, they amassed a collection of more than 2,500 artefacts and artworks. Many were acquired for them by art historian Bernard Berenson (1865–1959). The collection included works by some of the greatest artists of all time, including Titian (c. 1488/90–1576), Diego Velázquez (1599–1660), Raphael, Édouard Manet (1832–83), Botticelli, Matisse and Benvenuto Cellini (1500–71). Isabella and her husband, John Lowell Jack Gardner Jr. (1837–98) planned to open a private museum to house their art collection, but Jack died at just 61 years old. From then, Isabella supervised the construction of a Renaissance-style Venetian palazzo in Boston (the building plan is pictured left), with balconies and a courtyard abundant with lush plants. In 1901, the building was completed and, after had Isabella spent a year organising the displays, the Isabella Stewart Gardner Museum was opened to the public in 1903. Until her death, Isabella lived in an fourth-floor apartment in the same building. According to the terms of her will, the Gardner Museum was passed over to Boston as a public institution with the specification that the collection continues to be maintained exactly as she had organised it; nothing was to be added to it, removed or in any way rearranged.

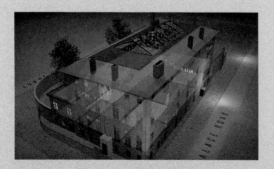

by Edgar Degas (1834–1917). Rough and unfinished, these are not much to look at to an untrained eye, and the thieves left far more valuable drawings by Michelangelo on nearby walls. Nonetheless, they snapped the drawings from their frames, leaving a pile of broken glass and splintered wood. They began to rip out some 17th-century Dutch paintings, but apparently experiencing some difficulty in doing so, they trampled them on the floor. They tried to open a glass case containing a Napoleonic battle flag, but when they could not do this, vindictively, they broke off an eagle-shaped finial from the top of the display case instead. Back on the ground floor, they grabbed a painting by Édouard Manet, *Chez Tortoni* (c. 1875). Finally, the crooks kicked open the security director's office, and ripped open the video recorders, then proceeded to remove any visual record of their faces or movements inside the museum. In a final, spiteful act, they placed the empty frame of the Manet painting on the security director's chair. This was probably meant as an insult all those in authority who ran the museum, to anyone who cared about art, and as a sign of their arrogance in pulling off the heist.

After 81 minutes, the two men left the museum. They left the building and emerged on to Palace Road once again, climbed with their 13 stolen works of art back into the waiting car, which then sped off. None of the artworks and artefacts have been seen since.

ABOVE: Karen Sangregory, former guard (top) and Charles Heidorn, former security foreman (bottom) at the Isabella Stewart Gardner Museum, in 2021.

Suspects

Lack of evidence meant that the case was too difficult for the police to solve, and the trail went cold. Four years later, demands were sent to the Gardner Museum's director, asking for a $2.6 million (£2 million) ransom. It was a fraction of the combined value of the works, so the museum directors agreed and followed the ransomer's instructions, by publishing a coded message in the Boston Globe newspaper, but they never heard anything again.

It is unlikely the thieves were commissioned to steal specific works of art: those they seized were not the most valuable in the gallery. Instead, the selection seems to have been random and opportune. When some artworks proved hard to remove, they were abandoned and others taken. Often more valuable works were hanging alongside them, but these were ignored. Furthermore, stealing to order is quite rare: of the many art thefts reported each year, police and art historians consider only a few dozen to have been commissioned in this way. In the absence

of a specific gang or individuals, there have been many theories of
who stole the artworks, including the Corsican and Boston branches
of the mafia, the IRA and James 'Whitey' Bulger, a Boston gangster,
but none have resulted in any arrests or even further evidence.

James 'Whitey' Bulger was an early suspect, who as well as being
a feared organised crime boss was also an FBI informant. He was also
linked to the IRA, an organisation that had that been involved in a
number of art thefts, the proceeds of which it used to finance its
activity. It was even hypothesised that Bulger had exploited his
connections inside the Boston Police to carry out the heist on the
IRA's behalf, and this is how the thieves managed to get hold of
genuine police uniforms. However, no solid evidence linked him to
the theft, but the possible Bulger connection is why some detectives
believe that the artworks are now in Ireland.

As the search continued, the FBI also looked into the Merlino
Gang, a Boston Mafia crime family. Undisclosed informants said that
George Reissfelder and Leonard DiMuzio, both Merlino Gang
members had been involved in the heist. This line of investigation,
however, could not easily be followed, as both died soon after the
robbery in 1991. DiMuzio was murdered and Reissfelder took a fatal
overdose of cocaine. Other Merlino associates were also looked at,
including Robert Guarente and Robert Gentile, whom the FBI
thought might have held the stolen artworks for some time.
Guarante's widow told the FBI that her husband was indeed in
possession of the paintings, but had handed them over to Gentile. As
a result, a search was undertaken of Gentile's house, but none of the
stolen art was found, and no information about the art was ever
forthcoming. In 1999, Carmello Merlino was arrested for an
attempted robbery of an armoured car depot, but despite being

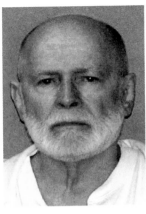

James 'Whitey' Bulger Jr

George Reissfelder

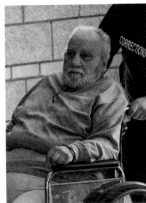

Robert Gentile

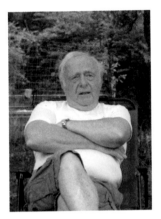

Myles Connor

David Turner

William P. Youngworth

offered a shorter sentence if the art was returned safely, he did not produce any, and he died in prison in 2005. David Turner, another Merlino accomplice, was another figure who might have been involved in the heist and the series of murders that followed it. Turner was positively identified by the two security guard witnesses as looking like one of the thieves they saw that night. In 1999, he was arrested and began a long prison sentence. Again, he was offered a shorter term in prison in return for giving up the artworks, but he also said nothing.

Bobby Donati worked with the Boston Mafia and also with a notorious art thief, Myles Connor. Although Connor was in prison when the heist took place, he had form in returning stolen art in exchange for a reduced sentence. Some detectives

Vincent Ferrara

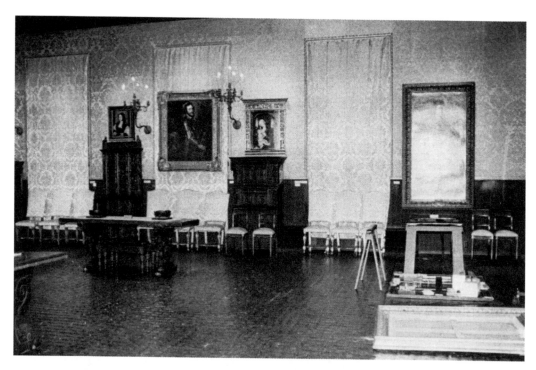

TOP: The interior of the musem soon after the robbery was discovered.

BOTTOM, LEFT: Anne Hawley, director emerita of the Isabella Stewart Gardner Museum.

BOTTOM, RIGHT: Investigators on the job after the heist.

were convinced that Donati may have organised the Gardner theft to gain leverage to have his associate, the gangster Vincent Ferrara, released, but in 1991, Donati was kidnapped and then murdered; a case that itself remains unsolved.

Rick Abath was the security guard who allowed the thieves to gain access to the museum. This aroused the suspicions of the investigators from the start. They alleged that before the thieves reached the museum, he opened one of the outer doors as a sign to them. Most of the stolen artworks had been hanging in the Dutch Room and the Short Gallery on the second floor, while the Blue Room on the first floor suffered only one loss: Manet's *Chez Torton*. The museum's motion detectors failed to pick up the thieves entering that room during the robbery, but they did indicate that the last person to have been in it was Abath as he made his rounds. No solid evidence incriminated him, but there were many questions that remained unanswered.

A history of involvement with similar crimes also led criminal and screenwriter Brian McDevitt to become a suspect in the heist.

BELOW: Part of the Isabella Gardner Museum was cordoned off as examinations were undertaken early on in the investigations.

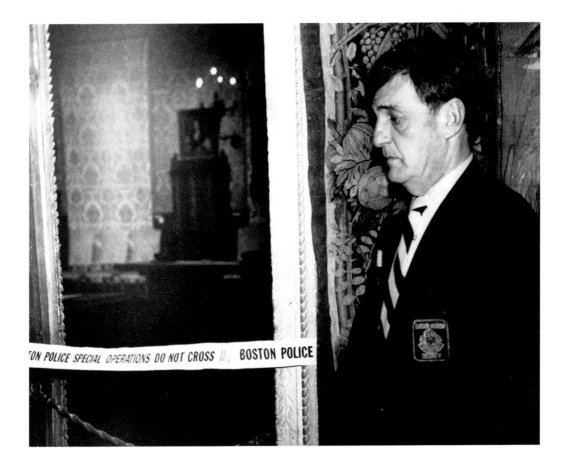

'ON POLICE SPECIAL OPERATIONS DO NOT CROSS BOSTON POLICE

In 1981, he had taken part in a failed robbery at the Hyde Collection in New York, when he tried to steal a Rembrandt while disguised as a FedEx driver. Although there are clear parallels, McDevitt, too, denied involvement and there is no tangible evidence to suggest he was involved.

In 1997, William Youngworth, an antiques dealer in Brighton, Michigan, declared that he had access to the stolen Gardner artwork, and with the room where it was stored illuminated by a torchlight, he showed a journalist from the *Boston Herald* called Tom Mashberg what he maintained was Rembrandt's *Storm on the Sea of Galilee*. This provoked a front page headline in the newspaper: 'We've Seen It?' The federal authorities began negotiations with Youngworth, but Mashberg could never be certain if the painting he saw was the genuine Rembrandt, and Youngworth made several tricky demands as his price for the restitution of the artwork, including the payment of $5 milllion/£4 million; exemption from prosecution for the theft; acquittal from any criminal charges that would otherwise be raised against him; and the release of his friend, the art thief Myles Connor, who was serving time in prison on drug charges. However, after several months, the deal collapsed when the FBI revealed that an analysis of a vial of paint fragments provided by Youngworth revealed that they did not come from a Rembrandt, as the man had claimed.

ABOVE: Blue Room highlights include works by John Singer Sargent (1856–1925), Ralph Wormeley Curtis, and Anders Zorn. Antonio Mancini's *The Standard Bearer of the Harvest Festival* is prominently featured on the right. The empty frame under *Portrait of Madame Auguste Manet* by Edouard Manet, on the left, marks where Manet's *Chez Tortoni* was stolen from during the 1990 Gardner heist.

The story now

Over the years there have been even more leads and suspects, but no one has been arrested, and the works from the Gardner Museum theft remain missing. In 2013, the FBI announced that they believed they knew who was behind the heist and offered a $5 million reward for information leading to the recovery of the artwork. Nothing substantial happened. Two years later, the police held a press conference, updating people on the state of the investigation. Following a tip, they searched Suffolk Downs racetrack in Boston, but found nothing. The FBI then claimed that they were aware of the thieves' identity, but that both suspects had since died, and no associates had been identified. The hiding place of the hoard has never been discovered and, despite the efforts of the FBI, no one has been charged or arrested, and so the biggest art theft in history remains an open case. There have been no sightings of the 13 items that were stolen that night in March 1990 from a vulnerable, discreet museum that was established as the result of one woman's dream and passion. It seems that they are as far from being found as ever.

ABOVE: In 1896 Isabella Stewart Gardner bought Rembrandt's *Self-Portrait, Age 23*. It was the painting that strengthened her decision to transform her private collection into a public museum. This is the Dutch Room; an assembly of some of northern Europe's greatest artists. In this room, she also entertained her friends.

Lost Landscape

At midnight on 31 December 1999, while fireworks were exploding all around to celebrate the start of the new millennium, a thief broke into the Ashmolean Museum in Oxford, England, and stole a painting.

It was a landscape by the French Post-Impressionist, Paul Cézanne (1839–1906), known by various French names, including *Paysage d'Auvers-sur-Oise*, or *Groupe de Maisons, Paysage d'Île de France*, but in the Ashmolean, it was labelled as *View of Auvers-sur-Oise*. It was painted in around 1879–80, several years after Cézanne had lived in Auvers-sur-Oise, a small village 28 kilometres (17 miles) to the north-west of Paris.

The painting depicts a valley. Bright green grass, yellow-green trees and a blue sky filled with clouds surround a group of loosely painted white houses with blue and orange roofs. In the distance, another hill, more houses and a church spire can be seen.

Where is it?

This question has a double meaning for this painting. The first is: where is the actual canvas now? The other is: where does it depict? The French art collector Victor Chocquet (1821–91) who was particularly enthusiastic about Cézanne's work, owned the painting. His wife Marie inherited it, and in 1899 the entire Chocquet collection was displayed in Paris, in an exhibition called *Auvers*. So, it has come to be commonly known as *View of Auvers-sur-Oise*, or *Paysage d'Auvers-sur-Oise*. On a bend of the River Oise, Auvers is famous as the place where Vincent van Gogh spent the last weeks of his life -- he painted his own *View of Auvers* in the year he died. Several other artists lived and painted there during the late 19th century, including Charles François Daubigny (1817–78), Camille Pissarro (1830–1903), Jean-Baptiste-Camille Corot and Cézanne.

From February 1873 until the spring of 1874, Cézanne, his then girlfriend, Hortense Fiquet (1850–1922) and their baby Paul (1872–1947), stayed in Auvers with Dr Paul Gachet (1828–1909), a physician and an amateur painter. Unusually for that era, Dr Gachet believed in both conventional and alternative medicine, and he befriended several leading progressive artists. He converted the attic of his

OPPOSITE: *View of Auvers-sur-Oise,* Paul Cézanne, 1879–80, oil on canvas, 46 x 55 cm (18 x 21⅔ in).

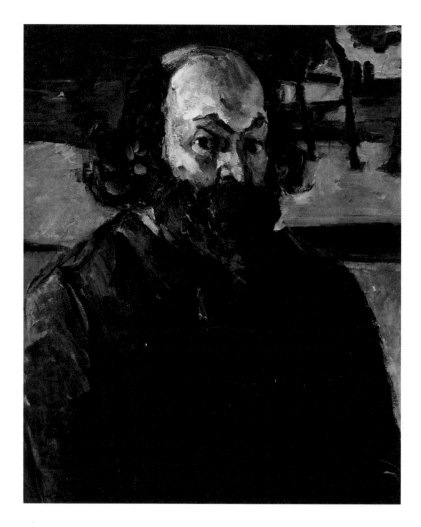

LEFT: *Self-Portrait*, Paul
Cézanne, c. 1875, oil on
canvas, 65 x 54 cm (25²⁄₃x
21¼ in), Musée d'Orsay,
Paris, France.

house in Auvers into a studio where they could gather, and he spent
two days each week at his medical practice in Paris. There he met
most of the artists who came to be called Impressionists and Post-
Impressionists. Gachet would also become famous for caring for van
Gogh for the last few weeks of the artist's life.

The doctor was exceptionally open-minded. Not many at the
time would have accepted an unmarried mother with her child and
the father, a penniless artist, into their homes, but he welcomed the
little family and was one of the few who admired Cézanne's work.
The artist enjoyed Gachet's friendship and hospitality, and spent his
time in Auvers painting around the village and at nearby Pontoise,
either alone or with his friend and mentor Camille Pissarro. The two
painters lived within walking distance of each other, and they often
worked side by side in the open air, capturing the landscapes around
them. Although their styles were different, Cézanne learned much

from Pissarro, including the use of a brighter palette and subtler contrasts than he had previously employed.

However, *View of Auvers-sur-Oise* was painted later, after Cézanne had departed Auvers and was living in Paris. In 1879–80, he was preparing to leave there and return to his native Aix-en-Provence in the south of France. During this period, Cézanne was often travelling back and forth between Provence and the Île-de-France (the surroundings of Paris that include Versailles and Fontainebleau), where he frequently painted. He rarely did so from memory, usually only working directly from a motif in front of him, so the labelling of this canvas as a view of Auvers or an Auvers landscape has frequently been questioned. Auvers was certainly the place where Cézanne began to develop his mature style during the late 1870s to early 1880s, and this painting fits into that period of stylistic transition, confirming its rough time frame, although many scholars are not so

sure about the location. Questions remain whether it really does represent Auvers, or instead the landscape of the Île de France, hence one of its alternative titles is *Paysage d'Île de France*.

Theft

As fireworks were going off to mark the turning of the 20th century into the 21st, a small group of figures climbed scaffolding which had been erected around an extension to the Ashmolean museum's library that was being built. As soon as they were on the roof, the burglars broke a skylight over a gallery and dropped a small smoke bomb into the museum. There followed a rope ladder, and then carrying a small bag containing a scalpel, tape, gloves and a portable fan, they climbed into the building. Once inside, they used the fan to spread the smoke, to obscure the view of any CCTV cameras or the museum's security guards. Then they went straight to Cézanne's *View of Auvers-sur-Oise*, slicing the canvas from its mount and smashing the empty frame on the floor. This done, they ascended the rope ladder, climbed down the scaffolding outside, and disappeared into the large celebratory Millennium Eve crowds.

ABOVE: Christopher Brown, CBE who was director of the Ashmolean Museum in Oxford, England at the time the painting was stolen.

Alarms had triggered during the burglary, but the smoke made the museum's security staff assume that there was a fire of some sort. Police and firefighters got to the museum just before 2am, and immediately entered the gallery, from which the smoke was by now dispersing. They found no trace of a fire, only the remains of the smoke bomb on the floor. As they rushed over to it, they noticed a flashing light on the wall next to a space where the Cézanne painting should have been. The police ascertained that *View of Auvers-sur-Oise* was the only artwork taken from a room that also displayed paintings by Pierre-Auguste Renoir (1841–1919), Auguste Rodin (1840–1917) and Henri de Toulouse-Lautrec (1864–1901). It was the only work by Cézanne in the Ashmolean, and valued by the museum at £3 million/$4 million, but the authorities believe that the thieves will never be able to sell the painting – if that was their intention – because of the extensive publicity surrounding the theft. It is probable that all along it had been stolen for someone's personal private collection.

Investigation

The Thames Valley Police allocated six officers to investigate the heist. With a lack of specialist resources, they also contacted art theft experts, and put customs officials at the country's airports and harbours on alert in case the thieves tried to send the painting out of the country.

Expecting the Ashmolean would receive a ransom demand, the investigators chose at first to withhold some details about the heist. Early on, the police got a tip that the stolen Cézanne had been spotted in a pub in the West Midlands, raising hope that they might be able to effect a rapid recovery. However, when officers were sent to the pub, they found that the sighting was a false alarm, and the canvas was a copy, its paint still wet.

Since then, there have been no productive leads and no reports from the police. With no further sightings of the painting, the investigation continues.

Q THE ASHMOLEAN MUSEUM

The Ashmolean Museum of Art and Archaeology (pictured above) in Oxford, England was Britain's first public museum and second university museum in the world. It owes its origins to the building erected from 1678–83, to house artefacts that Elias Ashmole (1617-92) had given to the University of Oxford in 1677. Ashmole was an inveterate collector, who had acquired a wealth of objects from gardeners, travellers and collectors. The museum opened on 24 May 1683, with a new building erected in 1841–45. The current museum was mainly instigated by British archaeologist and historian Sir Arthur Evans (1851–1941), who is most famous for unearthing the Minoan Palace of Knossos on the Greek island of Crete. Over the years, several new galleries have been added to the building to house further works of art and artefacts from around the world.

LEFT: Police video of the theft.

A Heist with a Hoist

In December 2005, a monumental, semi-abstract bronze statue by Henry Moore (1898–1986), worth over £3 million was stolen from the Henry Moore Foundation sculpture park in Hertfordshire, UK.

The massive work of art, created in 1969–70 – fairly late in Moore's career – was entitled *A Reclining Figure*. It was taken late at night and it was later conjectured by the police that a crane had been used to hoist the bulky 3.3 x 2.4 m- (11 x 8 ft-), 2-tonne (4000 lb) statue onto a Mercedes flat-bed lorry. Three men were captured on security cameras late on the dark winter's night. Officers investigating the theft believe that the statue could have been stolen for scrap.

Many of Moore's reclining figures evoke the landscape of his birthplace, their undulating curves resonant of the rolling hills of Yorkshire. He cast a total of seven *Reclining Nudes*.

The getaway

On that cold December night, the thieves spent nearly two hours stealing the huge bronze. Close to 11pm, CCTV cameras captured two vehicles: a Daihatsu four-wheel drive with a spotlight and the Mercedes flat-bed lorry, which may have been red, with a 'hi-ab' lifting crane on the back. Three men were caught on the film, one wearing a hooded jacket and another a baseball cap.

The thieves arrived at the sculpture park at approximately 9pm, then managed to hoist the statue and strap it on to the Mercedes lorry. At about 10.45pm, they drove it away. Later, the lorry was found abandoned on a housing estate in Harlow, Essex. Prior to the theft, it had been stolen from a building site in Roydon, Essex. The Metropolitan Police Arts and Antiques Squad said that they believed the work had been cut into pieces and melted down to be sold abroad for scrap, possibly for as little as £1,500 ($1,900). At the time, officers inspected numerous smelting furnaces to see if there was any trace of the work, but found nothing suspicious. Another theory is that the sculpture was stolen to order by a private collector, although the controllers of the Art Loss Register said that only two out of around three thousand of the cases they have ever investigated were stolen to order for people to keep. Speculation continues that it

OPPOSITE: The Henry Moore sculpture *Reclining Figure*, 1969-70, bronze, which was stolen from the artist's estate, now a museum, in 2005.

🔍 HENRY MOORE

Yorkshire-born and from a mining family, Henry Moore became famous for his massive, organic, semi-abstract bronze sculptures that have been placed in public spaces around the world. Less well known are Moore's many drawings, including some of Londoners sheltering from the Blitz in Underground stations during the Second World War. Influences on Moore's innovative techniques and style of art include non-Western art, especially ancient Mayan figures, and European modernism. Among the themes he returned to again and again were included the mother and child and the reclining figure. His forms became increasingly abstract as he produced works that evoked similarities between the human body and the landscape. One of his signature techniques was direct carving, a method inspired by his diverse sources of artistic influence. This involved the abandonment of traditional processes of modelling and casting, with artists instead working directly on their materials. Moore maintained that sculptors should respect the inherent properties of their materials, and allow these to show through in the finished work. He believed that each material has a life of its own, and felt that it was part of the artist's task to allow this energy to manifest itself through his work. He also loved the natural world and found frequent inspiration in objects such as pebbles, shells and bones, while his work conveys an image of humanity as a powerful natural force. In 1921, Moore won a scholarship to study at the Royal College of Art in London, and he left the north of England. A German air raid over London which damaged his Hampstead studio caused him to relocate to the quiet Hertfordshire village of Much Hadham in 1940. Over the rest of his life, he lived frugally, gradually adding extensions to his small cottage and garden, and after his death, his estate became the Henry Moore Foundation, a body set up to conserve his work, his home and studio and his reputation. The Foundation also supports the promotion of and education in the arts.

was cut up on the night, then shipped abroad, perhaps to Rotterdam and then possibly to China.

Late in 2023, the Henry Moore Foundation stated that: 'The theft of *Reclining Figure* from Perry Green in 2005 is still a source of great regret to us, and remains an open case. The work was never retrieved despite considerable efforts to find it. The Henry Moore Foundation has always co-operated fully with the police in the great hope it might be recovered, and it is registered with the National Art Loss Register. Security measures have been considerably increased at Perry Green since the work was taken, without compromising the enjoyment of the many visitors to Moore's beautiful former home.'

CHAPTER 10

Smash and Grab

In 2006, a new commercial art gallery, the Clark, opened in Cheshire. Scarcely a week later, three artworks by L.S. Lowry (1887–1976) were stolen, along with several other 20th-century paintings.

Three men, probably aged between 18 and 23, wearing stocking masks and dark clothes, smashed the gallery's plate-glass windows with a drain cover, and then snatched the paintings from the walls. The stolen artworks were: *Floating with Great Aunt Jane in the Void* (1973) and *The Last of the Sun in the Grange in Barrowdale* (1960), by Helen Bradley (1900–79); *St Ann's Square* (date unknown) by Arthur Delaney (1927–87); *Still Life with Fruit and Wine* (date unknown) by Mary Fedden (1915–2012); *Red Wedge* (1959) by Terry Frost (1915–2003); *Fishing Boats* (1960) by Alan Lowndes (1921–1978); *Collioure* (date unknown) and *Table Top* (date unknown) by Donald McIntyre (1923–2009); *Brighton Beach* (date unknown) and *Carousel* (date unknown) by Fred Yates (1922–2008); and Lowry's *Industrial Scene* (date unknown), *Industrial Scene with Figures* (1949), and *Two Women and Children* (1950).

Reward

After the theft, the gallery owner Bill Clark said: 'This was a show of everything I've got – it took me a long time to put the collection together. It's really devastating to have this happen after one week's trading.' He immediately offered a £25,000 ($31,000) reward for the recovery of the paintings and the conviction of the thieves. He and the investigators on the case are convinced that heist was a theft-to-order as the artworks the thieves took were the most valuable in the show. The largest of the Lowry works, an oil painting titled *Two Women and Children*, had already been bought for £115,000 ($144,000). It seems that the criminals obtained a catalogue and knew which paintings they wanted, but little more was ascertained after the works were whizzed away on that Thursday night, 28 September 2006. Leaving in a dark coloured car, the thieves vanished within a few minutes of breaking in, and the stolen works have not been seen since. They have not been sold in the legitimate art market, and if they turned up at auction, they would be seized. One theory is that they are being used as collateral for drug deals.

OPPOSITE: *Two Women and Children*, L.S. Lowry, 1950.

OVERLEAF: A selection of the stolen works.

Industrial Scene with Figures, L.S. Lowry, 1949

Red Wedge, Terry Frost, 1959

Brighton Beach, Fred Yates, date unknown

Fishing Boats, Alan Lowndes, 1960

TOP: The wall in the gallery where the Lowry artworks were displayed.

ABOVE: Bill Clark, the gallery owner.

RIGHT: Exterior view of gallery.

🔍 L.S. LOWRY

Laurence Stephen Lowry (pictured right) drew and painted
scenes from the Greater Manchester area, in north-west England,
close to where he lived. It was an industrial region and Lowry
developed a distinctive style of painting, becoming known for
his urban landscapes that he filled with thin, stylised human
figures that have often been nicknamed 'matchstick men'. The
anonymous figures cast no shadows, but they convey the tough
and monotonous daily lives of many who lived in the industrial
districts of northern England. In these paintings (such as *Going
to Work*, 1945, pictured below), Lowry included no indication
of the weather. He also painted empty landscapes, seascapes,
melancholy portraits and other works that were only found after
his death. Many of his critics described him as a 'Sunday painter'
and his work as repetitive, naïve and lacking in imagination, but
he had far more admirers than critics and, after his death, his art
became exceptionally sought after and valuable.

Lowry lived with his mother for much of his life and was a
solitary, semi-reclusive man who never married. His paintings
simply recorded the everyday existence of the working-class
northern community around him. An exceptionally modest
person, he rejected no less than five British honours he was
offered, including a knighthood in 1968.

Five Art Giants

Le Pigeon aux Petit Pois (Pigeon with Peas), sometimes called *Dove with Green Peas*, painted in 1911 by Picasso was stolen from the Musée d'Art Moderne de Paris on 20 May 2010.

It was one of five paintings taken at the same time, whose combined value amounts to approximately €104 million (about £89/$113 million). As well as the Picasso, the other paintings the thieves got away with include *Pastoral* (1906) by Henri Matisse, *Olive Tree near L'Éstaque* (1906) by Georges Braque, *Woman with a Fan* (1919) by Amedeo Modigliani (1884–1920) and *Still Life with a Candlestick* (1922) by Fernand Léger.

The three security guards on duty did not hear or see anything amiss, and it was not until just before 7am that morning that the theft was discovered. When the museum's CCTV footage was studied, a solitary masked intruder clad in black was seen taking the paintings. Further investigation revealed that the padlock of a grille had been removed along with glass from a window, and that rather than simply cutting them out, great care seemed to have been taken in removing the paintings from their frames. Neither the motion sensor nor the alarm that should have been triggered by the thief breaking in was in working order.

Cat burglar

As many newspapers reported at the time, the paintings were by such well-known artists that it would be difficult to sell them on the open market, but there are some parts of the world where stolen artefacts can be passed on more easily. In February 2017, a 49-year-old cat burglar, Vjeran Tomic was arrested for the robbery and given an eight-year prison sentence. He had confessed to the theft of the five paintings from the Paris Museum of Modern Art. Tomic's acrobatic techniques led him to be nicknamed Spiderman by the media. At the trial, Tomic claimed that his original commission had been only for the theft of the Léger, but that when he found the museum's alarm system was faulty, he took the impromptu decision to take more. One of the judges said that he had stolen 'cultural goods belonging to humankind's artistic heritage'. Two of Tomic's collaborators were also given prison sentences. Jean-Michel Corvez,

OPPOSITE: Five stolen paintings by five giants of the art world.

Pigeon with Peas, Pablo Picasso, 1911

Pastoral, Henri Matisse, 1906

Olive Tree Near L'Éstaque, Georges Braque, 1906

Still Life with a Candlestick,
Fernand Léger, 1922

Woman with a Fan,
Amedeo Modigliani, 1919

61, an antiques dealer who probably commissioned the robbery and who stored the paintings afterwards, was sentenced to seven years in prison. Yonathan Birn, 40, a clockmaker, was given six years imprisonment, also for his part in storing the stolen paintings. Birn, who confessed to receiving the stolen goods, claimed that he threw them away, but the police doubted his claim. Corvez and Birn were also fined €150,000 (about $160,000/£130,000), and Tomic was given a fine of €200,000 (about $215,000/£170,000). All three were ordered to pay €104 million (about $110/£89 million) to the city of Paris as compensation for the paintings' estimated value at the time they were stolen.

ABOVE: Cat burglar Vjeran Tomic was given an eight-year prison sentence.

The Spider

Tomic was used to working alone, and preferred stealing jewellery, as hiding and selling it was not difficult, but over time he became more and more confident and began to feel invincible, despite having already been arrested and spent a year in prison. As a teenager, Tomic had wanted to be an artist. He loved art, especially Matisse, but even though many of the opulent apartments that he broke into had valuable works of art on display, he rarely took them, as he realised that they would be extremely hard to sell. He had however, stolen a few works of art. In the autumn of 2000, for instance, using a crossbow with ropes, he took two paintings by Renoir, one by André Derain (1880–1954), one by Maurice Utrillo (1883–1955), a painting by Braque and several others. He did not make a habit of this and it was not until a decade later that he once again stole valuable works of art.

In May 2010, Tomic was walking near the Seine when he came upon the Musée d'Art Moderne. He studied the windows and decided that he could easily break in. A few days later, he visited the museum. He roamed the galleries, evaluating the artworks as he went, and observing that the motion detectors which were supposed to flash from green to red when people passed by, were in a number of cases simply stuck on green.

By the time Tomic had decided to steal from the Musée d'Art Moderne, he had a sponsor: Jean Michel Corvez, who owned several businesses in France. Over a number of years, Tomic had sold Corvez tens of thousands of euros worth of stolen goods, including jewellery, gold and art. Corvez gave Tomic a list of artists his clients would want work by, and nicknamed him *l'Araignée*; the Spider. So, after he had been to the Musée d'Art Moderne, Tomic visited Corvez. The businessman went through the works of art he wanted and

offered Tomic $40,000 (about £32,000) to get them. The burglar then began to make plans for the robbery.

On 14 May 2010, in the early hours, Tomic approached a window that faced onto a boulevard used by skateboarders during the day. At around 3am, a guard briefly made a quick patrol of the galleries, then walked away. Tomic draped a piece of fabric on the outside of the window conceal what he was doing. Then, beneath it, he prepared the window over six nights. First, he applied paint-stripping acid on to the frame, which exposed the screw heads. Then he applied another solution to get rid of any rust. Next, Tomic removed the screws and then filled the holes with modelling clay which was the same brown colour as the window frame. Before dawn on 20 May, he returned wearing a hooded sweatshirt, and with the help of two suction cups, pulled out the window. Tomic then used bolt cutters to break what was holding a grate and entered the museum, easily dodging the few motion detectors that were in working order. Then he left and paused nearby for fifteen minutes, to make sure that he had not set off any alarms. Tomic used the same entry point to return inside the museum, where, first of all, he took the Léger. Next, he saw Matisse's *Pastoral*, and removed it from the wall, followed by Modigliani's *Woman with a Fan*. He then took down *Pigeon with Peas*, by Picasso and *Olive Tree Near l'Éstaque*, by Braque. He almost stole Modigliani's *Woman with Blue Eyes*, but he could not remove the frame from the wall.

BELOW, TOP: Yonathan Birn was sentenced to six years in prison for storing the paintings, even though he claimed that he threw them away.

BELOW, BOTTOM: Jean-Michel Corvez was sentenced to seven years in prison.

He had so many canvases, it took him two trips to carry them out of the museum to his car parked nearby. Later that morning, he met Corvez in an underground car park in Bastille. When he realised that Tomic had stolen five paintings, rather than just the expected Léger, he was shocked and uneasy. Nevertheless, he took the Léger and the Modigliani and agreed to store the three other paintings for Tomic.

Before the day was out news of the heist had spread across the world. The stolen artworks were estimated to be worth more than $70 million/£56 million. The initial police assessment noted a number of interesting aspects of the break-in: the burglar had taken the time to line up the window screws neatly in a corner, which was said to indicate the 'cold-bloodedness' of the burglary. The five

paintings the thief had chosen to steal happened to be among the prize artworks in the museum collection, which might suggest that whoever was responsible possessed 'a sophisticated knowledge of the works'.

A few days after the robbery, Tomic was growing increasingly anxious that the police were following him. In spite of this he went to meet Corvez again to collect his payment, and the businessman handed him a shoebox crammed with banknotes. Taking a taxi, Tomic went to the apartment of a woman he knew, taping his cash – €40,000 (about $43,000/£34,000) in total – to the bottom of chair seat and then spending the night. Six months later, the police did not have much in the way of leads in the case, but they happened to be working on a separate investigation into Tomic's activities. During it, they discovered by chance that he had stolen these five paintings. On 7 December 2010, they tailed him to the Centre Georges Pompidou, one of the largest modern art galleries in Europe, and watched him as he scrutinised the emergency exits. The next day he was still under surveillance when he bought two suction cups, glue and a pair of heavy workmen's gloves. Strangely however, they chose not to arrest him on the spot.

Meanwhile, Tomic was increasingly sceptical about Corvez's actions, so he secretly taped a conversation they had, in order to have evidence that could incriminate him for his involvement in the crime. Corvez sold the Modigliani to Yonathan Birn, who owned a small shop in the Marais district of Paris. The three men then tried to find buyers for the other works. In May 2011, an anonymous

BELOW, LEFT: A police officer climbs on the broken windows of the Paris Museum of Modern Art after the theft.

BELOW RIGHT AND OPPOSITE: The police search for clues as they pack up and return the frames of the stolen paintings to the museum.

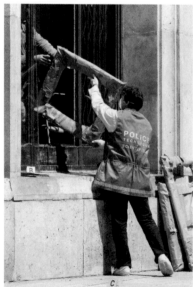

informant told investigators that Corvez had the missing paintings. By then, the police had Tomic under close surveillance. They arrested him and raided his apartment, where they found incriminating equipment, including a climbing harness and a grappling hook. Under interrogation, Tomic confessed to the Musée d'Art Moderne burglary. At about the same time, the police raided Corvez's gallery and Birn's watch shop, but the five paintings were not found.

According to Birn, soon after the police raid, he recovered the Modigliani. Panicking that he was about to be apprehended, he destroyed all the paintings, and dumped the remains in a rubbish bin near his shop. However, even his wife said later that she doubted the truth of his claim.

In court, Tomic proclaimed: 'These paintings, they are my property, these are my works.' He bragged about how easy it had been for him to break into the museum, but he refused to reveal where the paintings were. Despite the criminals' capture, all five of the paintings remain missing. It is still not known whether they were sold, hidden or destroyed. Since the burglary, the city of Paris has intensified security at the 14 museums it operates.

Q CUBISM

One of the most significant art movements in 20th-century Western art, Cubism was initiated in 1907 by Picasso after he had seen retrospective exhibitions of work by Cézanne and Gauguin and exhibits of African and Iberian masks in museums. That year, he painted a huge work, *Les Demoiselles d'Avignon*. The painting shocked those who saw it, but it inspired some artists, including Georges Braque, who until then, had painted in a Fauvist style, as in Olive Tree Near l'Éstaque. Together, Braque and Picasso invented a new approach to art that abandoned traditional representations of perspective. Rather than painting from one angle, Cubists represented what they saw from several angles on their flat canvases, so that everything looked fragmented. To minimise any confusion, initially, Picasso and Braque used restricted colour palettes. Other artists, including Fernand Léger, produced their own form of Cubism. Cubism was one of the most important art movements of the 20th century, and so probably extra desirable for thieves such as Tomic.

Egyptian Mystery

In 2010, an 1887 work by Vincent van Gogh, known as *Poppy Flowers* or *Vase and Flowers* or *Vase with Viscaria*, was cut from its frame and taken from the Mohamed Mahmoud Khalil Museum in Cairo.

At the time, the painting was said to be worth $50 million (£32 million). The Mohamed Mahmoud Khalil Museum is located in a palace built in Cairo in 1920 for Egyptian politician Mohammed Mahmoud Khalil Pasha and his wife Emiline Lock. Containing their vast art collection, the palace was opened as a museum in the couple's memory on 23 July 1962. From 1971 to 1993, the building was used as government offices, but was then restored and reinstated as a museum. Its collection includes artwork by some of the greatest 19th-century European artists, including Paul Gauguin, Edgar Degas, Claude Monet (1840–1926), Pierre-Auguste Renoir, Auguste Rodin and Vincent van Gogh.

Employees arrested

After the 2010 theft, 12 culture ministry employees, including Deputy Culture Minister Mohsen Shaalan, were found guilty of negligence because prosecutors claimed that they caused or enabled the conditions that allowed the crime to happen. Each was sentenced to three years in jail, but they were all subsequently released on bail pending appeal. After the appeal, Shaalan served a one-year prison term, ending in 2013. All the accused employees were barred from travel in the immediate aftermath.

The same painting had been stolen previously in 1977 and recovered ten years later in Kuwait. The details of that theft have never been publicised. When the painting was returned after this first theft, Egypt's then interior minister announced that three Egyptians had been detained by the police and had admitted that they knew where the canvas was hidden. There was no information on whether the men were accused or put on trial. Since the 2010 theft, however, the painting has not been seen and its whereabouts remain unknown. When it was taken on a Saturday in broad daylight, the museum had had just ten visitors all day. The staff initially suspected two Italian tourists, who had been seen to visit the

OPPOSITE: *Poppy Flowers* or *Vase and Flowers* or *Vase with Viscaria*, Vincent van Gogh, 1887.

OPPOSITE, TOP: The interior of the Mohamed Mahmoud Khalil Museum.

OPPOSITE, BOTTOM: Two Italian visitors were stopped as they tried to board a plane to Italy at Cairo International Airport, but later released.

BELOW, TOP: The museum's collection of paintings include French Impressionist paintings by artists such as Alfred Sisley, Camille Pissarro, Claude Monet and Pierre-Auguste Renoir.

BELOW, BOTTOM: Egypt's top prosecutor (centre) ordered the detention of the country's deputy culture minister in connection with the theft.

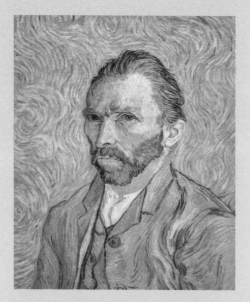

🔍 VAN GOGH'S INSPIRATION

The small, vibrantly coloured painting *Poppy Flowers* demonstrates van Gogh's admiration of French artist Adolphe Monticelli (1824–86), whose work he first saw on his arrival in Paris in 1886, the year of Monticelli's death. Monticelli had a highly individual Romantic style of painting, with a richly coloured palette, and textured and glazed surfaces. As well as having a profound effect on van Gogh's work, he also influenced his friend Paul Cézanne. After seeing Monticelli's paintings, van Gogh changed his dark palette for a much brighter one and a thicker and bolder application of paint. Later, he said about Monticelli, 'I sometimes think I am really continuing that man.' In 1890, van Gogh and his brother Theo were especially involved in the first book to be published about Monticelli and his art.

toilets before rushing quickly out of the building. The two young men were stopped as they attempted to board a plane to Italy at Cairo International Airport.

In the event, nothing was found on them or in their luggage; they had simply been part of a tour group visiting the museum. They were allowed to leave Egypt with no charges made against them.

Defective security system

In 2023, an Egyptian billionaire, Naguib Sawiris, offered one million Egyptian pounds (around $20,000 or £16,000) as a reward for information leading to the return of the stolen painting. Investigations

into the theft have found there had been 'flagrant shortcomings' in the museum's security, with only seven out of forty-three security cameras working properly. In addition, every painting was protected by an alarm, but when the painting was taken, not a single one sounded. According to a top Egyptian prosecutor, the alarms and cameras had been broken for a while. State prosecutors had previously voiced concerns about the need to improve security in all of Cairo's museums after nine paintings had been stolen from the Muhammad Ali Palace in 2009. Officials at the Mohamed Mahmoud Kahlil Museum had, it seems, been searching for spare parts to repair the security system, but at the time of the theft, had not found any.

So the mystery of the theft continues. The case remains open, and van Gogh's colourful painting remains missing.

OPPOSITE: In 2023, Egyptian billionaire, Naguib Sawiris, offered 1,000,000 Egyptian pounds as a reward for information leading to the return of the painting.

BELOW: The Muhammad Ali Palace, from where nine paintings were stolen in 2009.

Chinese Art Heists

Between 2010 and 2015, a series of art heists occurred in a number of different European and Scandinavian cities. All the stolen items were Chinese art treasures.

In Stockholm on a foggy summer's evening in 2010, a gang of thieves set fire to several cars. The blazes were a ruse to fool the police. They rushed to investigate the burning cars, the thieves took advantage of the distraction to dash towards Drottningholm Palace, the residence of the Swedish royal family. The gang broke into the Chinese Pavilion inside the grounds, from which they seized numerous ancient works of art and artefacts which formed part of the permanent state collection. Leaving the pavilion, they leapt on to mopeds, sped to a nearby lake, abandoned their bikes in the water and then escaped in a speedboat. It was all over in less than six minutes.

A month later, thieves targeted the KODE museum in Bergen, Norway. Located on Bergen's central square, the institution is not far from the local police headquarters. The intruders broke in through a glass ceiling and abseiled down inside the museum. Then, as the alarms failed to sound, they snatched 56 objects from the Chinese Collection. The stealing of Chinese artefacts seemed to be becoming a regular occurrence, as in 2012, the Oriental Museum at Durham University and Cambridge University's Fitzwilliam Museum, both in England, were also looted for their Chinese treasures.

'Inept'

On 5 April 2012, thieves spent 30 minutes chiselling into the Oriental Museum at Durham University through an outside wall, then took just one minute to snatch two Chinese artefacts. By the light of torches, the thieves went without hesitation directly to two separate cabinets containing a 1769 jade bowl and a Dehua porcelain figurine, both objects from the Qing dynasty, China's last imperial dynasty. The thieves escaped before the police arrived.

Eight days later, on 13 April, thieves broke in to the Fitzwilliam Museum at Cambridge University. They gained access via the rear of the building, shattered glass display cabinets and escaped with artefacts described as being of 'incalculable cultural significance'.

OPPOSITE, TOP: Drottningholm Palace, Sweden, from where numerous artworks were stolen in 2010.

OPPOSITE, BOTTOM: The Chinese Pavilion in Drottningholm Palace, which was broken into.

HUVUDVÅNINGEN

Karl X Gustavs galleri

Slottskyrkan

Innergård

Huvudtrappa

Innergård

Biblioteket

Mot trädgården

TOP: Drottningholm Palace layout, main floor.

BOTTOM: Inside the Chinese Pavilion in Drottningholm Palace.

LEFT: Guards outside the Chinese Pavilion, Drottningholm Palace, following the raid.

BELOW: Durham University Oriental Museum.

The items, dating from the Ming and Qing dynasties, included 18 pieces of Chinese jade, among them a 16th-century carved buffalo, 17th-century carved horse and a green and brown carved elephant. Experts valued the treasures at up to almost £18 million/$22 million and assessed that they could be worth tens of millions more on the Chinese auction market.

In September 2013, a large gang of criminals was rounded up by the police. They included 14 men who planned, hid and sold the items. The two who broke into the museum in Durham were named as Adrian Stanton and Lee Wildman. Stanton was caught in another, unrelated burglary, wearing shorts, which exposed a distinctive tattoo on his leg. However, by the time of their arrest, both men had forgotten exactly where they had buried the artefacts on

ABOVE: Fitzwilliam Museum at Cambridge University.

LEFT: The scene of the crime at Fitzwilliam Museum.

some wasteland. The two objects were later found by a member of the public. The pair, who had been hired by the gang to burgle the museum, were described as 'inept' by the press, and at Durham Crown Court, Judge Christopher Prince reflected: 'Lawyers with many years' experience have not seen a case where thieves have hidden property where they just could not find it afterwards, let alone property of this cultural importance and enormous value.'

All the men were convicted, most to several years imprisonment, but the rest of the Cambridge treasures have never been found. They are believed to have been stored in a safehouse in Purfleet in Essex, and then they disappeared. Over the course of three trials, it was discovered that a web of connections to the heist spanned England, Scotland, Northern Ireland, the Irish Republic, France, the United States and Germany.

Historic palace

In 2013, the KODE was broken into again, with thieves stealing 22 further Chinese antiquities. Two years later, the Chinese Museum of the Château de Fontainebleau in Paris was also robbed. The château is a sprawling, opulent former royal estate just outside Paris, with more than 1,500 rooms. Between the 12th and 19th centuries, it was home to 34 kings and two emperors. The thieves however, ignored the palace itself and went straight to the grand Chinese Museum in the grounds created in 1863 by Empress Eugénie, the wife of Napoleon III. One of the world's oldest museums specifically dedicated to Asian art, the museum was stocked with works so rare that their value was considered immeasurable, but many of the items on display had originally been plundered from China in 1860, by British and French soldiers during the sacking of Beijing's Old Summer Palace.

LEFT: In September 2013, the police arrested a large gang of criminals, including fourteen men who took on distinct roles within the planning, hiding and selling of the items.

Before dawn in March 2015, the thieves made their way quickly to the south-west wing of the building, where they gained access by smashing a window. Once inside, they snatched 22 items from the collection, among them some of its most valuable artefacts, including porcelain vases; a coral, gold and turquoise mandala; a Chimera in cloisonné enamel and a replica of a crown of the King of Siam (now Thailand) which had been given to Napoleon III in 1861. In just seven minutes, the robbers had left the scene and disappeared. The police were on the scene within minutes, only to be faced with the foamy contents of a fire extinguisher that the thieves had emptied as they left to obscure their fingerprints and footprints.

Audacious and proficient

Since the Fontainebleau heist, the spate of robberies of Chinese artefacts has continued throughout Europe. Many of these are daring and dramatic, but their full extent is not widely known because many do not reach the headlines. Security officials and museum boards are generally not keen to disclose details to the public, or to highlight their own failures, both because these are embarrassing and the necessary preventative security improvements are highly expensive.

ABOVE: Kode Art Museum in Bergen, which was raided once in 2010 and again in 2013.

OPPOSITE, TOP AND BOTTOM: The exterior and interior of the sumptuous Château de Fontainebleau.

At first, each robbery seemed isolated and disparate. Then a pattern began to emerge. Every incident was shockingly audacious, and each involved Chinese art and artefacts. The thefts we do know about have marked similarities. The criminals are fast, breaking into the buildings swiftly and taking what they want efficiently. Most seem to be stealing to order, probably from a list, as some of the most valuable objects are often left behind. In each case, all art and antiquities taken have been Chinese, and most were pillaged from China by foreign armies, especially during the Second Opium War. Many of these artworks are so well documented that they would be difficult to sell or display after being stolen. In most cases the items have not been seen since they were taken. Some experts suggest that the heists are probably part of a larger campaign to repatriate lost Chinese artefacts, but this has not been proved and the mystery surrounding the thefts and their perpetrators continues to pose difficult questions for museums and investigators alike.

ABOVE: The Chinese Museum inside the Château de Fontainebleau, from where the artefacts were stolen.

ABOVE: A replica of a crown of the King of Siam, which was given to the French Emperor in 1861 (left), pavilion-shaped antique (middle), and ornate beaded artefact that once belonged to the Empress Eugenie, wife of Napoleon III (right), were all stolen.

Twelve zodiac heads

In recent years in China, several national campaigns to recover artworks have been initiated. For example, one of the country's most influential commercial corporations, the state-run China Poly Group, which acts for the Chinese defence manufacturing industry and runs the world's third largest art auction house, initiated a programme intended to locate and retrieve lost Chinese art. Other, lesser-known campaigns are probably underway to a similar end

In particular, the Chinese people mourn the loss of 12 bronze fountainheads portraying the Chinese zodiac which were formerly in the old Summer Palace. Originally part of a water clock, the heads spouted water from their mouths to indicate the time, but they were pillaged at the end of the Second Opium War. Probably designed by the Italian Jesuit artist Giuseppe Castiglione (1688–1766) for the Qianlong emperor, the bronze-cast heads have long been desperately sought by the Chinese for repatriation. The tiger, monkey and ox came up for sale in 2000 in a Hong Kong auction house, and were snapped up by China Poly, while the pig's head was located in New York. Two further heads, the rat and the rabbit, which had been in the collection of the French fashion designer Yves Saint Laurent (1936–2008), were auctioned off after his death. Before the

ABOVE: Chimera,
cloisonné enamel, dating
from the reign of Emperor
Qianlong in the 17th
century.

sale, Christie's, which was selling the works in Paris, received a letter from the Chinese government asking that the rat and rabbit heads be withdrawn. The auction house refused and on the closing day of the sale, in February 2009, the rat and rabbit bronzes sold for the equivalent of nearly $40 million (£32 million). A few days later, the winning bidder refused to pay for them. The case was cloaked in mystery, but in 2013, the rat and rabbit heads returned to Beijing. The horse was repatriated in 2020, but the dragon, dog, sheep, snake and rooster have yet to be returned.

Returning to the Republic

Huang Nubo is a Chinese businessman, entrepreneur, poet, mountaineer and founder and chairman of the Beijing Zhongkun Investment Group. His passion for Chinese art and culture found an outlet in 'the *National Treasures Coming Home* campaign', which concentrates on finding and retrieving lost artefacts for China. After the second burglary at KODE, he donated $1.6 million (£1.3 million) to the museum. Shortly after this, the museum decided to loan seven of the marble columns taken from the Chinese Imperial Summer Palace to Beijing University on a permanent basis. Since the series of robberies began, several museums have made changes. Many have strengthened their security. Others have begun to question the lawfulness of having such artworks and artefacts in their collection at

114 ART HEIST

all, and others have taken the decision to quietly send back all such items they hold back to China.

Despite continued investigations, the perpetrators of these crimes remain at large, and some of the mystery surrounding 'The Great Chinese Art Heist' remains unresolved.

ABOVE: The original twelve figures can be seen in this drawing of the Old Summer Palace fountain.

OVERLEAF: The twelve zodiac heads.

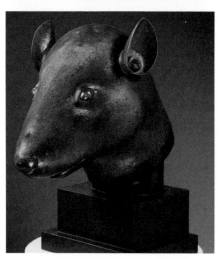

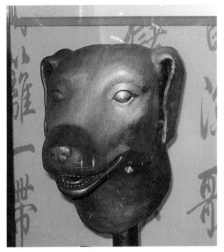

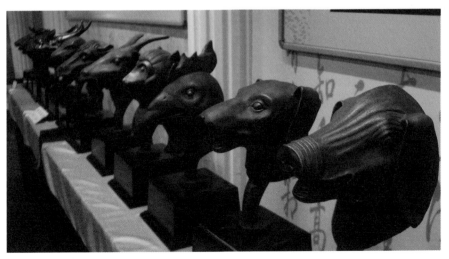

Bronze Burglary

Two Forms (Divided Circle), is a large bronze
sculpture, approximately 237 x 234 x 54 cm
(93 x 92 x 21 in), created by Barbara Hepworth
(1903–75) in 1969.

Hepworth cast six numbered copies of the artwork, and kept one
herself. Completed six years before she died in a fire at her studio
in St Ives, Cornwall, in 1975, *Divided Circle* is classed as one of her
late works. Hepworth was one of the UK's most important modern
sculptors, and her work is displayed in museums and public spaces
around the world. She once said: 'You can climb through the
Divided Circle – you don't need to do it physically to experience it.'
It is a work characteristic of Hepworth's late period, including two
vertical bronze semi-circles that form a large broken circle that is
approximately 2 m (6 ft 7 in) in diameter. These hollow components
were welded to a bronze base.

One of the copies was kept on permanent display in Dulwich
Park, South London, for more than 40 years. It was placed in a
clearing in the centre of the park and became a familiar sight for
locals and visitors to the area. Then, late on the night of Monday
19-20 December 2011, the huge work was stolen from its place in
the park, which sadly was not covered by CCTV. Investigators
believe that the burglary was carried out by metal thieves, and
fear that the sculpture was sold for scrap. It was insured for
£500,000 ($625,000), and Southwark Council offered a reward
of £1,000 ($1,200) for any information that led to the arrest and
sentence of those found guilty. The amount was later increased
to £5,000 ($6,000) by the Hepworth estate.

Scrap metal

Early the next morning, staff at the park were horrified to find an
empty plinth where the Hepworth artwork had stood. The thieves
had gained entry to the park by breaking the padlock of the gate,
then apparently drove up to the sculpture. It was the only major
work of art in the park that surrounds Dulwich Picture Gallery. They
must have used an extremely strong industrial saw to remove the
work from its plinth, and its size and renown would make it almost

OPPOSITE: *Two Forms
(Divided Circle)*, Barbara
Hepworth, designed 1969,
cast 1970.

TWO FORMS
(DIVIDED CIRCLE)

Barbara Hepworth
1970

impossible to sell on. Therefore, experts deduce that it would have been sold for scrap metal, which would be amount to just a tiny percentage of the real value of the complete work.

Rising prices for copper, lead and bronze have generated a huge increase in metal theft, from locations ranging from cemeteries to railway lines, and buildings to works of art. Police forces around the world have set up specific metal-theft taskforces to deal with such incidents.

RIGHT: Dulwich Park, where the sculpture was displayed.

BELOW: The empty plinth where the Hepworth sculpture stood for 40 years.

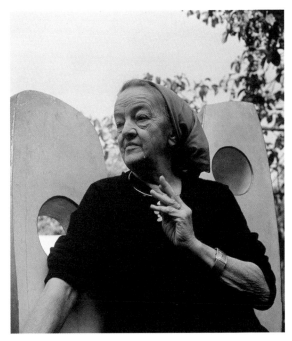

LEFT: Dame Barbara Hepworth in 1970.

BELOW: *Three Perpetual Chords* by Conrad Shawcross was installed in 2015 to replace the stolen sculpture.

Caught But Still Lost

Seven extremely important artworks by six well-known artists were stolen from the Kunsthal museum in Rotterdam, the Netherlands during the early hours of 16 October 2012.

The robbery made international headlines, but what initially seemed like a sophisticated heist by professionals, turned out to have been carried out by a handful of inexperienced Romanian criminals who had little idea about what they were doing. Their speciality was burgling houses, not stealing valuable, internationally recognised works of art, and they knew virtually nothing about selling them on.

Paintings by Picasso, Matisse, Gauguin, Meyer de Haan (1852–95), Freud and Monet were stolen. Art experts said that the value of the heist at the Kunsthal museum amounted to tens of millions of pounds. One security expert described the museum as a 'nightmare to protect', and conjectured that the crooks must have spent months making complex plans before undertaking the robbery.

Famous paintings

The stolen artworks were by famous artists from the nineteenth and twentieth centuries. They included: *Harlequin Head*, 1971, pen and brush in black ink, coloured pencil and pastel on thick brown wove paper by Pablo Picasso; *Reading Girl in White and Yellow*, 1919, oil on canvas mounted on board by Henri Matisse; *Waterloo Bridge, London*, 1901, pastel on brown laid paper and *Charing Cross Bridge, London*, 1901, pastel on brown grey laid paper, both by Claude Monet; *Girl in Front of Open Window*, 1888, oil on canvas by Paul Gauguin; *Self-Portrait*, c. 1889–91, oil on canvas by Meyer de Haan and *Woman with Eyes Closed (Emily Bearn)*, 2002, oil on canvas by Lucian Freud. Estimated to be worth a total of between €50 million and €100 million ($53 million and $108 million/£42 and £86 million), the works were on display as part of an exhibition at the Kunsthal to celebrate the twentieth anniversary of its opening. Named *Avant-Gardes*, the exhibition included 150 artworks from the Triton Foundation Collection owned by the Cordia family, one of the wealthiest families in the Netherlands. The collection is of the top 200 art collections in the world in terms of size, it was initially

OPPOSITE: Some of the artworks stolen from the Kunsthal in Rotterdam in October 2012.

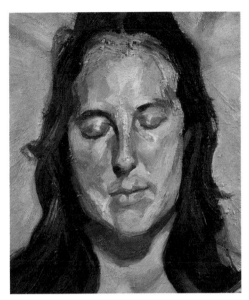
Woman with Eyes Closed, Lucian Freud, 2002

Charing Cross Bridge, London, Claude Monet, 1901

Waterloo Bridge, London, Claude Monet, 1901

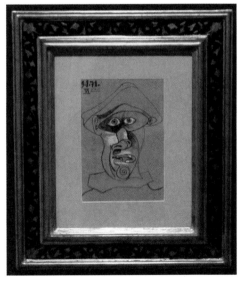
Harlequin Head, Pablo Picasso, 1971

collected in the 1970s. Later, the family decided to share their art collection with the public, not by founding their own museum, but by lending out the collection.

Mystery

As soon as those who ran the Kunsthal became aware of the robbery, the artworks were listed on the Art Loss Register, making it impossible to sell them in the legitimate art market. At the time, investigators speculated that the paintings may have been 'stolen to order' by an art collector and were now hanging on a private wall, or that they had been taken to be used as a bargaining tool.

The robbery took place at about 3am on 16 October 2012. Although the alarm had been set off, the thieves had escaped by the time the police arrived on the scene. As soon as the burglary was discovered, the gallery was closed to allow forensic experts to search for clues. Although the Kunsthal is a large building featuring glass partitions, giving people on the outside a clear view some of the works, there were no security guards on duty at night. Instead, cameras and alarms were supposed to do all the work of surveillance and protection. If the alarms were triggered, mobile guards from a nearby security company could reach the scene quickly, while the system also automatically alerted the police.

ABOVE, OPPOSITE TOP LEFT: The interior of the Kunsthal Museum, Rotterdam.

OPPOSITE TOP RIGHT, BOTTOM LEFT, BOTTOM RIGHT: Investigators at work in the museum grounds.

The huge and brazen art heist made headline news and remained a mystery for a year.

What really happened

A year after the paintings were stolen, the full truth about the details of the heist was uncovered.

A 28-year-old Romanian, Radu Dogaru, had moved to Rotterdam earlier in 2012. In his small Romanian village, Radu and his family were known as thieves. Two of Radu's friends, Eugen Darie and Alexandru Bitu, came from a small town near the village. They too, moved to Rotterdam and from the moment they arrived in the Netherlands, the men began burgling, while their girlfriends, who travelled with them to Rotterdam, worked as prostitutes. Adrian Procop and Petre Condrat were also friends of Radu's who had also made the move to Rotterdam. Back home in Romania, they are all known as *interlopi*, which is Romanian for criminals, and they all had extensive criminal records for a string of serious offences, including violence, threats, possession of arms, vandalism and theft.

Ten days before the Kunsthal burglary, on Saturday 6 October, Radu and Eugen drove around Rotterdam looking for places to burgle. Posters attracted them to the Kunsthal, and there they realised that paintings were both portable and valuable. Radu planned for three of them to carry out the actual burglary. The next day, Radu, Eugen and Adrian returned to the museum with Eugen's girlfriend, Andreea. While Eugen and Andreea walked through the museum looking at the exhibits, Radu and Adrian studied the security. Over the next few days, they made several trips to the area around the museum, including after dark to assess the footfall, which was when they discovered that the Kunsthal had no guards on duty at night. They bought large black raffia bags in which to carry

the paintings they would take, as well as sim cards to use in their phones on the evening of the robbery and black hoodies. Less than a week before the planned break-in, on Thursday 11 October, Radu paid a last visit to the museum on his own. Over the course of two hours, he went through every detail of the plan carefully, selecting seven moderately sized paintings that had no cameras on them and that would be manageable to carry.

The night of Monday 15 October was rainy, with a thick cloud cover. Radu and Adrian were to commit the burglary, while Eugen took care of transport. He borrowed a car from Alexandru, and parked it not far from the Kunsthal, with the boot unlocked. Radu and Adrian broke in through the Kunsthal's fire door, entering the museum at 3.16am. The seven artworks they had selected were fixed to the wall by cables that were easy to detach. Two minutes and

ABOVE, LEFT: Alexandru Bitu

ABOVE: Olga Dogaru

Q AVANT-GARDES

From 7 October 2012 to 20 January 2013, the *Avant-Gardes* exhibition at the Kunsthal Rotterdam featured the Triton Foundation's collection of artworks by some of the most important and influential artists from the late 19th century to the present day. It had never been seen in public before, and yet had developed an international reputation. The art ranged from Impressionist to Expressionist, Cubist to Constructivist and Post-Impressionist to contemporary art. The exhibition comprised over 150 works of international art by more than 100 different artists. These included Marcel Duchamp (1887–1968), Piet Mondrian (1872–1944), Georges Braque, Willem de Kooning (1904–97), Vincent van Gogh, Juan Gris (1887–1927), Pierre Bonnard (1867–1947), Wassily Kandinsky, Picasso, Matisse and Gauguin. The exhibition gave an overview of the broad scope and achievements of visual artists over time.

ABOVE: The house of Olga Dogaru, in Carcaliu village, eastern Romania, where the artworks were incinerated.

LEFT: Evidence from Olga's house was analysed in a laboratory of the National History Museum in Bucharest.

48 seconds later, Radu and Adrian were back outside, loading their loot into the car. Eugen drove them, but became nervous and dropped them 30 minutes' walk away from Radu's house. Around two hours after the Romanians had left the museum, the police arrived, and two hours after that, the first TV news report announced news of the burglary; the robbery became international news.

Within a day, the two men had Alexandru's car destroyed. Realising that this robbery was bigger than they had originally thought, they left the country. They tried to sell the paintings, but an art historian who they approached to value them, realised what they were and tipped off the Romanian police.

Artworks destroyed

All six of the Romanian men were charged with the theft. Olga Dogaru, Radu's mother, later said that she burned the paintings in a stove after her son was arrested in her attempt to destroy evidence against him. Her husband was already serving a prison sentence for assault; she did not want to lose her son to prison as well. Soon after, Radu called her and told her that he would get a reduced sentence if he returned the paintings. It was too late. Forensic specialists inspected Olga's stove and found evidence that on the night of 17 February, the seven artworks that had been stolen from the Kunsthal museum had been incinerated in Olga's stove and reduced to ashes.

Q CHANGING ART HISTORY

The works of art stolen from the Kunsthal museum by the thoughtless thieves represent some of the most prominent names in art of the late nineteenth and early twentieth centuries. Monet, Gauguin, Picasso and Matisse in particular, are well-known to have changed the path of art, influencing countless ensuing artists. As a consequence, any works by them, let alone such fine examples, are worth a great deal of money. They are not only works of art in their own right, but examples of how, when and why art history changed.

BELOW: A Romanian forensic expert looks at photographs of evidence, canvas and nails contained in the ash of Olga's stove, proving that she had burned the paintings as she claimed.

Andy Warhol Prints

Between 2008 and 2016, more than 40 prints by Andy Warhol (1928–87) were stolen from sites in three different countries around the world.

Most of the robberies were in the United States, but two were taken in Germany, from the boot of a gallery owner's car, and a further two – a Campbell's Soup can and a portrait of Marilyn Monroe – were stolen from the Andy Warhol Museum of Art in Medzilaborce, Slovakia.

Warhol was one of the most prominent figures in the Pop Art movement that began in London in 1956 and gathered momentum in America from the 1960s. Bringing commercial art techniques into fine art, his colourful depictions of contemporary consumer culture changed art forever. He also became just as recognisable for his unique appearance, his quirky personality and his witty, often insightful comments. He attracted many characters to his studio in New York City, which he called The Factory. Located in four separate sites between 1963 and 1987, it became renowned for the parties Warhol held there that attracted artists, musicians, models, celebrities and an eclectic mix of those on the fringes of society. After beginning his career as a highly successful commercial illustrator, Warhol became a fine artist, first painting, then printmaking prints and finally producing videos just before his early death at just 58.

Athletes, camouflage and flowers

One night in September 2009, ten screen-printed portraits of athletes created by Warhol in 1977 were stolen from the home of the art collector and friend of Warhol, Richard Weisman. The series Athletes had been commissioned by Weisman, and comprised ten brightly coloured portraits of the most celebrated contemporary athletes: Muhammad Ali, Kareem Abdul-Jabbar, Chris Evert, Rod Gilbert, O.J. Simpson, Pelé, Tom Seaver, Willie Shoemaker, Dorothy Hamill and Jack Nicklaus. The year before the prints were stolen, Weisman had tried to sell them for $3 million (£2.4 million). The thieves also took a portrait of Weisman painted by Warhol. The most audacious robbery was in 2010, when thieves burrowed underground into the New York City home of another art collector and grabbed eight signed prints from the Camouflage series that Warhol had produced in 1986.

OPPOSITE: Andy Warhol in front of some of the screen prints from his Athletes series.

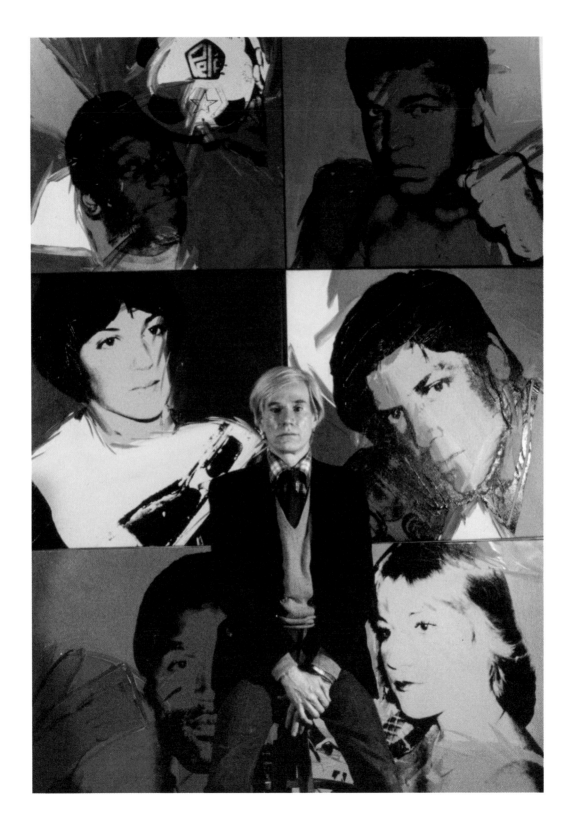

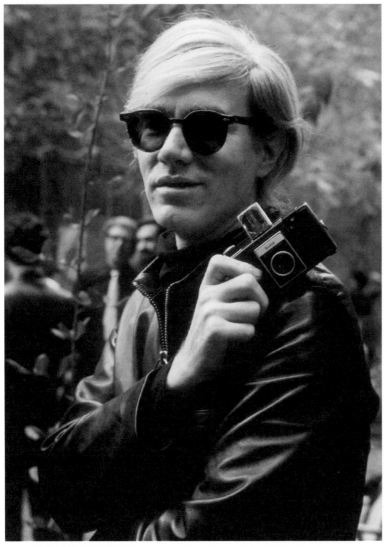

TOP: Springfield Art Museum, Missouri, USA, from where some of his Soup Cans prints were stolen in 2016.

BOTTOM: Portrait of Andy Warhol.

🔍 WARHOL'S SCREEN PRINTS

In 1962, Warhol began to experiment with screen printing. At the time, the technique was common in commercial art, but rarely used in fine art. Warhol was attracted to the method because it allowed him to evoke the processes of mass production, which fitted his belief that art should be accessible to all. He began by making screen prints of his own drawings of dollar bills, and then he printed images based on photographs of celebrities, such as Marilyn Monroe, Elvis Presley and Elizabeth Taylor. He made thousands of prints of all sorts of objects and people from the world around him, such as his famous Campbell's Soup Cans (pictured here), because they were available to everyone, rich or poor. He printed images of bottles of Coca Cola, sports personalities, political figures, cows and flowers that he took from a photograph in the June 1964 issue of *Modern Photography*.

In screen printing, the artist makes stencils and places them on the gauze, or 'silk' screen. A squeegee is used to push thick ink through the screen. It covers the paper beneath, but not where the stencils are. For multi-coloured prints, the stencils are either cut or changed, the screen washed and a new colour pushed through with the squeegee. Warhol always used vibrant, unnatural colours for his screen prints.

At the end of April 2012, the original screen that Warhol had used to create his Flowers series was one of 18 works of art stolen in Detroit's Corktown neighbourhood. A local art collector had temporarily stored them in his business there. The other artworks taken along with the Warhol screen were by contemporary artists including Francesco Clemente (b. 1952) and Joseph Beuys (1921–86). Overall, the heist was worth around $2 million (£1.6 million).

Copies

In 2015, nine original Warhol prints were stolen from the premises of the film company Moviola in Los Angeles. They were replaced with copies, but this went undetected for years. The screen prints, worth an estimated $350,000 (£280,000) were from Warhol's 1983 series Endangered Species and his 1980 series, Ten Portraits of Jews of the Twentieth Century. The theft was only discovered months later after one of the prints was taken to be reframed. Staff at the framing company noticed that the print was indistinct and lacked a print number and Warhol's signature. In April the following year, thieves broke into the Springfield Art Museum in Missouri and stole seven of Warhol's Campbell's Soup Cans prints from a set of ten. While the

entire set of ten was worth approximately $500,000 (£400,000), the seven that were stolen were worth less than this. Nonetheless, they were extremely valuable to the thieves. Experts say that because Warhol's works are often prints, the rapidly improving quality of printing has enabled criminals to produce fakes that are detectable to experts, but are rarely discernible to anyone else.

Other Heists

Some art heists are kept quiet and hardly publicised. This can be for several reasons, including that the gallery, museum or owners of the stolen goods do not want to attract negative publicity, or to advertise their apparent lax security. The following are two examples of these, first in a public museum and the other in a private property.

Secret Tunnels

In July 2002, Paraguay in South America hosted the biggest art exhibition in its history, in the National Museum of Fine Arts in Asuncion. The grand spectacle drew art lovers and collectors from across the country and beyond. Unfortunately, a gang of thieves planned to help themselves to a number of the works that were on display – and their plan worked.

The robbery took months of planning and preparation, involving the digging of a 3 m (10 ft) deep, 30.5 m (100 ft) long tunnel and renting a shop 25 m (80 ft) from the museum. The gang members who rented this posed as businessmen, using false names, and the authorities later deduced that they must have recruited several people to help them dig the tunnel, that ran from beneath the shop, directly to the museum. After two months of digging, the tunnel was ready, and on 30 July 2002, the thieves walked along it and entered the museum undetected.

It was night, so there were no visitors or museum staff in the building. The men walked through the exhibition and helped themselves to 12 paintings. The value of these works at the time was estimated to be $1 million (£800,000). They included *Woman's Head* by Étienne Adolphe Piot (1831–1910), *Self-Portrait* by Tintoretto (1518–94), *The Virgin Mary and Jesus* by Gustave Courbet and a self-portrait by Esteban Murillo (1617–82).

In 2008, The National Centre for Cultural Heritage Protection at INTERPOL's Argentina Bureau was informed that one of the works of art from the 2002 Paraguay theft was being offered for sale in the city of Posadas, in Argentina's Misiones province. Detectives and local staff of the Argentine Federal Police carried out an operation to

OPPOSITE: A self-portrait by the Venetian Renaissance artist Tintoretto was stolen from Paraguay in 2002. This is another self-portrait by the same artist painted in 1688 and part of the collection of the Musée du Louvre, Paris, France.

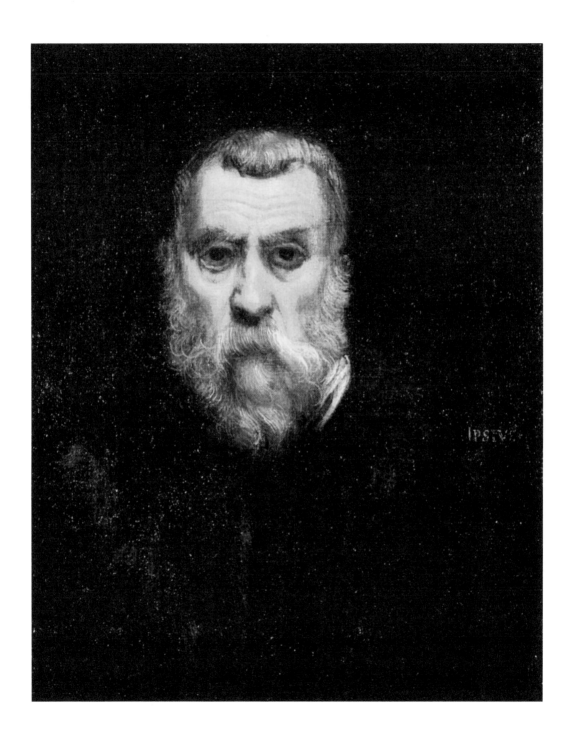

ABOVE: *Madeleine Leaning on Her Elbow with Flowers in Her Hair*, Renoir, 1918, stolen from a private home in Houston in 2011.

recover the oil painting. It was in perfect condition and discovered to be *San Gerónimo*, painted in c. 1500 by an anonymous artist. It is the only painting from the heist that has been found so far.

Renoir

On 8 September 2011, an oil painting by French Impressionist Pierre-Auguste Renoir was stolen from a private home in Houston, USA. Valued at approximately $1 million (£800,000), the 1918 painting, *Madeleine Leaning on Her Elbow with Flowers in Her Hair*, was typical of Renoir's later style, and was taken during the course of an armed robbery. The painting's owner was upstairs watching television when she was disturbed by the noise of the intruder entering. On going downstairs to find out the cause, she came face-to-face with an armed man in a ski mask. The robber, who forced entry through the back door of the home, was described as a white male, between 18 and 26 years old, who was armed with a semi-automatic handgun.

Since then, there have been no sightings of the painting, despite the FBI's adding it to their Top Ten list of missing artworks in their Stolen Art File and announcing a reward of up to $50,000 (£40,000) for information leading to its recovery. The work is also on the international Art Loss Register and INTERPOL's Works of Art database, which alert art dealers, gallery owners and auction houses about missing and stolen artwork.

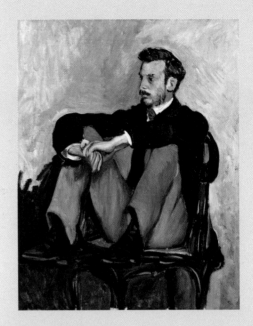

Q LATE STYLE

After 1890, when he began to suffer the pain of rheumatoid arthritis, Auguste Renoir (1841–1919) (portrait above, painted by Frédéric Bazille, 1867) moved away from his earlier Impressionist style and instead applied thin brush strokes in strong colours such as reds and oranges. Whereas before he had painted with smooth contours, he became less concerned with outlines and instead took a sketchier approach. His subjects were always cheerful and included portraits of lively and beautiful young women. Madeleine was a young French girl from the village of Cagnes-sur-Mer, in southern France where Renoir lived in later life in the hope that the warmth of the sun would alleviate his crippling symptoms. She became one of his favourite models.

2 Found

Up until now in this book, most of the stolen artworks have not been recovered, and the crimes remain unsolved. Happily, there are even more stories of artworks and artefacts being stolen and then found. Some of the most famous works of art in the world are among these, including *The Scream* by Edvard Munch and Leonardo's *Mona Lisa*. It might not be a coincidence that these two works are among the most famous and admired in the world. Art theft continues to be a problem for investigators and a way in which the unscrupulous often think they can make millions. Some do of course, and some manage to use the art as bargaining tools for shorter prison sentences. Often though, as we know, the particularly famous works become too 'hot' to move on. Once they are in the Art Loss Register, most conscientious auctioneers, museums and private buyers would not touch them. But there are always the unscrupulous. Police and specialist investigators, not to mention private owners and those in charge of galleries and museums, are always overjoyed when stolen art and artefacts are rediscovered and returned, and the following part of the book relays some of these happier stories, where stolen art and artefacts have been recovered, often for the benefit of us all.

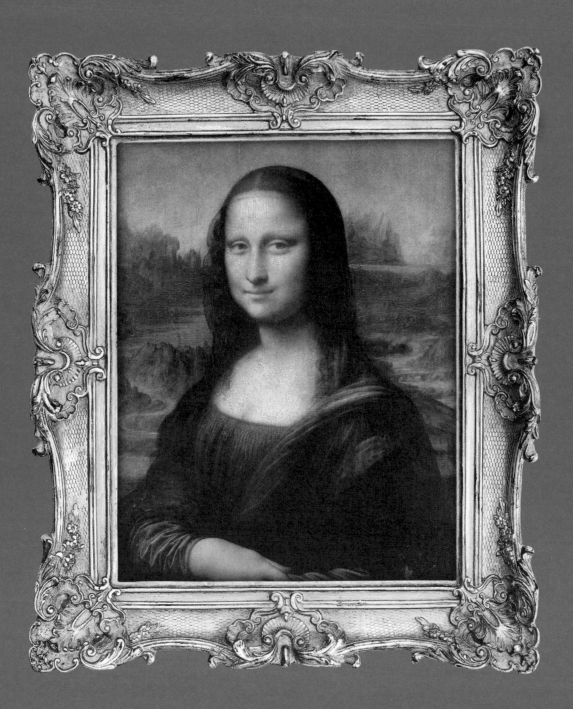

Art Icon

In 1911, the *Mona Lisa* was stolen. The work, possibly
the most famous painting in the world, was created
by Italian painter, draughtsman, engineer, scientist,
theorist, sculptor and architect Leonardo da Vinci (1452–
1519) in c.1503–06, although he may have continued
work on it until c.1517.

Leonard used oils to paint the portrait on white
Lombardy poplar wood, and the subject of the *Mona Lisa*
is commonly believed to be the noblewoman Lisa del
Giocondo, although the Giocondo family never came
into possession of the painting. Leonardo also employed
a unique method of delicate, soft shading, known as
sfumato, (from the Italian word *sfumare*, meaning 'to tone
down' or 'to evaporate like smoke'). Using it, Leonardo
created subtle gradations, without lines or borders between colours
and tones.

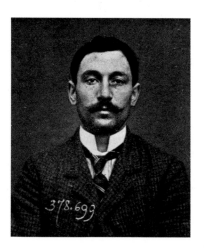

ABOVE: Vincent Peruggia, the handyman who walked out of the Lourve with the *Mona Lisa* wrapped in his work smock.

OPPOSITE: More than 10 million visitors a year flock to the Louvre, and the *Mona Lisa* is the main attraction for a huge number of them.

For many years, the painting hung relatively unnoticed in the
Musée du Louvre in Paris. Then, on 20 August 1911, a 29-year-old
Italian handyman who was working in the Louvre, Vincenzo
Peruggia, finished his shift and hid inside an art supply cupboard.
After the museum closed, he carefully lifted the painting from the
wall, removed it from its wood and glass fame and wrapped it in his
work smock. Then he tried to leave the museum, but found he could
not open the door. Luckily for him, a plumber saw him fumbling and
opened the door for him.

The next day, museum staff did not realise that the Mona Lisa
was missing. Paintings were often removed for renovation, to be
photographed for the gallery's inventory, or to be sent to other
museums on loan, so the first people to see the empty space on the
wall assumed that everything was fine. Then finally, a curator asked
where the painting had gone, and when nobody could give a reliable
answer, it became clear that the work had been stolen, and the police
were called.

News of the disappearance of the painting provoked a public
uproar. Magazines and newspapers splashed photographs of the
portrait across their front pages, and detectives swarmed all over the
Louvre searching for fingerprints and questioning potential

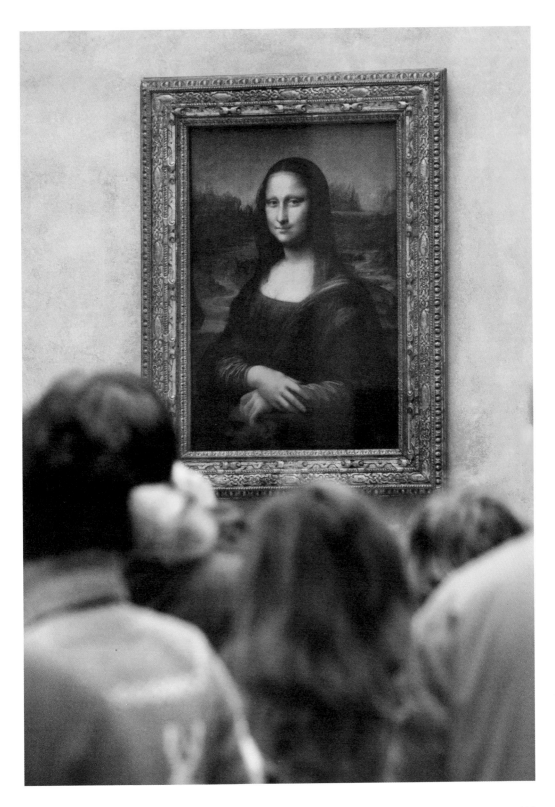

witnesses. Cars, pedestrians and even passengers aboard steamers were stopped and searched at checkpoints, while the police issued wanted posters across France and beyond. The Musée du Louvre was shut for a week, and when it reopened, thousands of visitors swarmed in, all wanting to gain a glimpse of the empty wall where the famous Leonardo painting had been hanging.

Despite the intensity of the search, the police investigation found nothing. However, they did identify several suspects, including

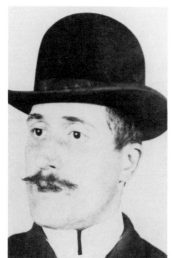

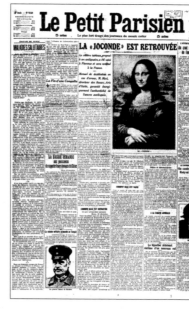

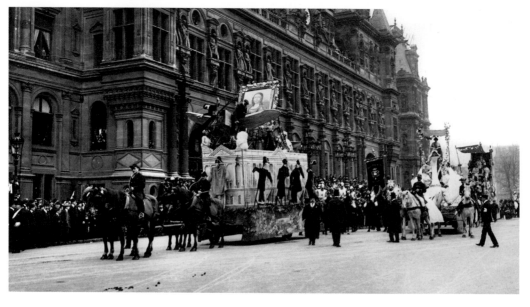

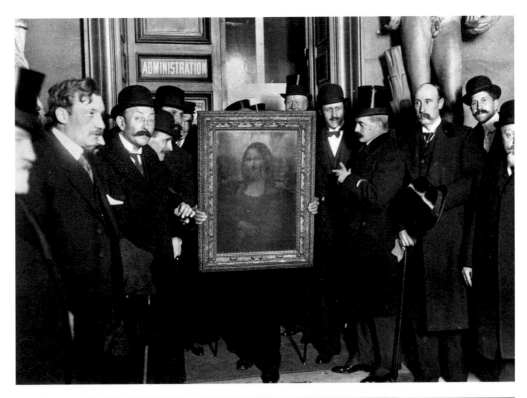

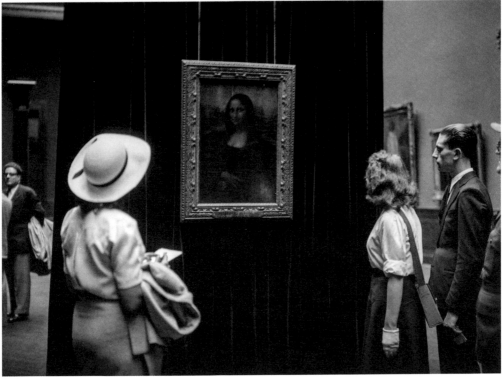

Guillaume Apollinaire, an avant-garde poet who had once declared that the Louvre should be burned down. He was arrested in September 1911 after police connected him to a previous theft of two ancient statuettes that had been appropriated from the Louvre by his secretary. While being questioned, Apollinaire, apparently inadvertently implicated his friend Picasso, who had bought the statuettes from his secretary to use as references in his art. There was no real evidence against them, and the two men were later cleared of any suspicion.

Peruggia hid the painting in his lodgings for two years. Then, in December 1913, he thought he had a buyer. Using the fake name 'Leonard', he travelled to Florence to meet an art dealer in his hotel room. The dealer brought the director of the Uffizi gallery and the pair watched, wide-eyed, as Peruggia produced the *Mona Lisa* from beneath a false base of his suitcase. The experts agreed to buy it, but in reality, they alerted the authorities and the next morning, Peruggia was arrested. He had already been interviewed about the theft twice previously, but the police decided that he was not a serious suspect.

After a whirlwind tour around Italy, the *Mona Lisa* was eventually returned to the Louvre in January 1914. Peruggia was charged with theft and faced trial in Italy. For part of his testimony, he declared that it had been a sense of patriotism that moved him to steal the painting, which he mistakenly thought had been looted from his native Italy during the Napoleonic era. In fact, Leonardo had taken the *Mona Lisa* with him to France when he moved there in 1516, and the French king, François I, had bought it legitimately. Peruggia was sentenced to one year and fifteen days in prison, but he had served just seven months of that sentence, when he was released on appeal. He later fought in the Italian army during the First World War, eventually returning to France, where he died in 1925.

Peruggia's heist made a celebrity out of *Mona Lisa*. At least 120,000 people went to see the painting over the first two days after it was returned to the Louvre. Columns were written about its subject's mysterious smile, her eyes that follow everyone around the room, her hands, her lack of eyebrows, the perspective of the background, its size, its mysterious atmosphere and Leonardo's *sfumato* technique. It was soon referenced in drawings, prints, advertisements, postcards, books, songs and films and became first mass art icon. Kept in a protected, climate-controlled box and shielded by bulletproof glass, museum guards are always close by, as more than 10 million visitors each year enter the doors of the Musée du Louvre, and the majority of those go to see the *Mona Lisa*, the most famous painting in the world.

OPPOSITE, TOP: *Mona Lisa* is now hung in a secure, climate-controlled box and protected by bulletproof glass. Museum guards are constantly close by as visitors shuffle past to catch a glimpse of the most famous painting in the world.

OPPOSITE, BOTTOM: The Louvre Pyramid at dusk, the main entrance for visitors who wish to see the famous artwork.

CHAPTER 19

Scream!

Another of the world's most famous works of art, *The Scream*, painted in 1893 by Norwegian artist Edvard Munch (1863–1944) has been stolen, not once but twice.

The angst-ridden face in the painting has become one of the most iconic images of art, viewed by many as symbolising the anxiety of the human condition. A prolific yet enduringly anxious and depressed artist, Munch had a troubled upbringing, which led to his melancholy when he was older. His childhood was eclipsed by illness, bereavement and the fear of inheriting a family mental condition. Both the artist's mother and older sister died prematurely and his father, a Christian fundamentalist, told the boy that these deaths were acts of divine punishment. This contributed greatly to his later angst and preoccupation with death, grief and vulnerability. His artworks became filled with strong colours, distortions and ambiguous ideas. Each of them expresses various emotional and psychological conditions. His work became particularly influential in the Expressionist movement.

Munch conceived the idea for *The Scream* in Kristiania (now Oslo). The tormented face is widely identified with the anguish of the human soul. In 1892, he wrote in his diary:

> One evening, I was walking along the road with two friends – the sun was setting – suddenly the sky turned blood red – I paused, feeling exhausted, and leaned on the fence – there was blood and tongues of fire above the blue-black fjord and the city – my friends walked on, and I stood there trembling with anxiety – and I sensed an infinite scream passing through nature.

There are four versions of *The Scream*, two of them painted images and two created in pastels. The first painted version was the first to be exhibited, and this was the work, in the collection of the National Gallery of Norway in Oslo, that was stolen. Inscribed on it in almost indiscernible pencil are the words 'Kan kun være malet af en gal Mand!' ('Could only have been painted by a madman'). Munch's first pastel version created in that same year, which it is thought may have been a preliminary study, is in the collection of the Munch Museum, which is also in Oslo. The second pastel version was created in 1895,

OPPOSITE: *The Scream*, Edvard Munch, 1893, oil, tempera and pastel on cardboard, Nasjonalgalleriet, Oslo, Norway.

148 ART HEIST

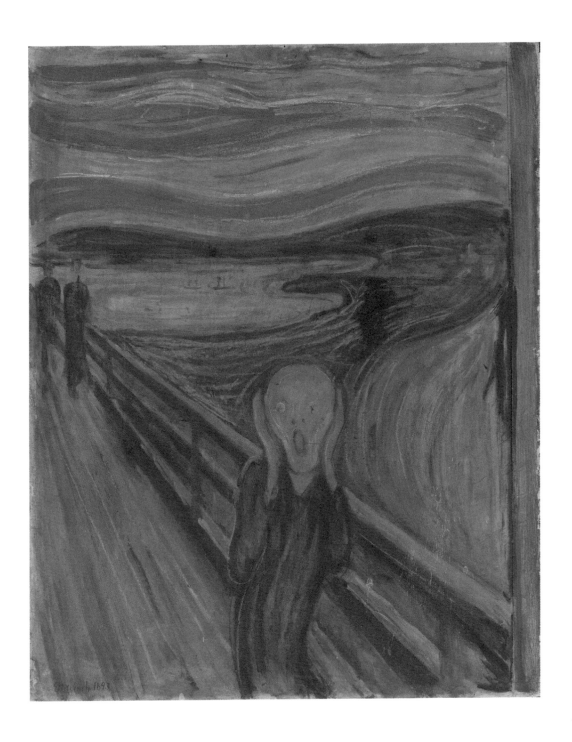

and the second painted version was produced in 1910, at a time when Munch was returning to some of his earlier ideas as sources of inspiration.

12 February 1994 was the day that the 1994 Winter Olympics opened in Lillehammer, Norway. It also saw two men break into the National Gallery in Oslo, and steal the gallery's version of *The Scream*. The thieves left a note saying: 'Thanks for the poor security.' As part of the Olympic festivities, the painting had been transferred down to a gallery on the lower second storey. To steal it the thieves had climbed a ladder, from which they had fallen, then climbed back up, broken a window and then grabbed the artwork.

A month later, the thieves contacted the gallery and demanded a ransom of one million dollaras (£800,000), but museum officials refused to pay. With help from the British police and the Getty Museum, Norwegian police set up an operation to fool the criminals. As a result, the painting was recovered undamaged in May. In January 1996, four men were sentenced for their parts in the theft, including Pål Enger, who also had a conviction for the theft of Munch's *Love and Pain* in 1988. However, the men were released on appeal on legal grounds, as the British agents involved in the undercover operation were there illegally, having used false identities to enter Norway.

A decade later, on 22 August 2004, the later 1910 version of *The Scream* was stolen. Masked gunmen entered the Munch Museum in Oslo in broad daylight and took it, along with Munch's 1894-95 painting *Madonna*. A bystander snapped photographs of the robbers as they ran to their car with the stolen works. In April 2005, Norwegian police made an arrest in connection with the theft, but there was still no trace of the paintings. A rumour started spreading that they had been burned by the thieves, but even so, that June, the city government of Oslo offered a reward of two million Norwegian krone (approximately $182,000/£145,000) for any information leading to the recovery of the paintings. Nothing happened. Then, early in 2006, six men were put on trial, charged with either assisting tin the planning of the heist or participating in it. Three of the men were found guilty and received prison sentences of between four and eight years, and two of them, Bjørn Hoen and Petter Tharaldsen, were further ordered to pay compensation of 750 million kroner (approximately $68 million/£55 million) to the City of Oslo. The Munch Museum remained closed for almost a year while its security systems were overhauled.

At the end of August that year, Norwegian police announced that they had recovered both *The Scream* and *Madonna*, and damage to them 'was much less than feared'. *The Scream* had some moisture

OPPOSITE, TOP: *The Scream*, Edvard Munch, 1910, tempera on board, The Munch Museum, Oslo, Norway.

OPPOSITE, BOTTOM LEFT: The Munch Museum, Oslo, Norway, from where the second theft of *The Scream* took place in 2004.

OPPOSITE, BOTTOM RIGHT: Nasjonalgalleriet, site of the first theft of *The Scream* in 1994, Oslo, Norway.

damage and *Madonna* was torn and had a couple of small holes in it. Even before the paintings underwent repair and restoration, they were exhibited at the Munch Museum for five days. Over 5,000 visitors viewed the damaged paintings. Once repaired, the paintings went back on permanent display in May 2008.

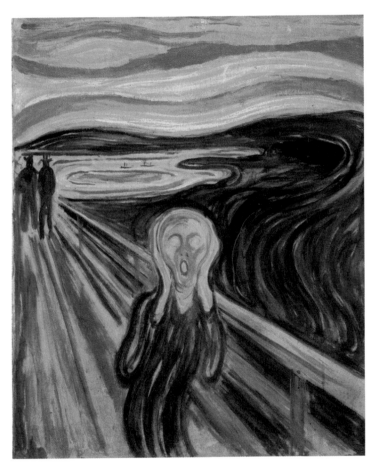

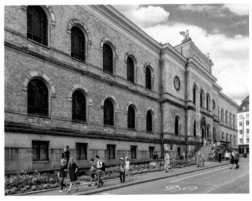

Guns and a Boat

Three days before Christmas, on 22 December 2000, three men went into the Swedish National Museum in Stockholm, one holding a machine gun, the other two carrying handguns. They held up security, while accomplices on the other side of the city set off two car bombs.

Local police rushed to the scene of the car bombs, while further members of the gang were laying spikes on the roads around the museum. One of the criminals stood guard inside the museum with a gun, as the two others located the paintings they had planned to steal. They were in and out of the museum within half an hour. When the men had taken the paintings, they escaped to a motorboat

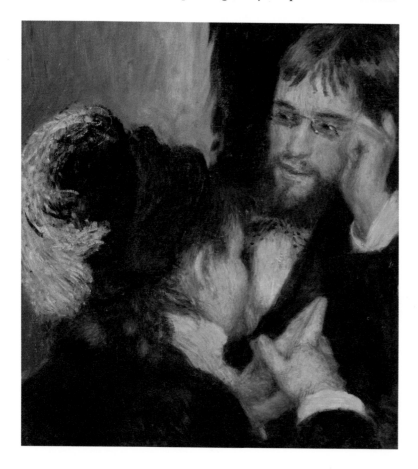

LEFT: *Conversation*, which was stolen, just before Christmas in 2000, but thankfully recovered by chance in 2005, was painted by Renoir.

waiting nearby (the museum is on the waterfront), and sped away.

The paintings the robbers took were a self-portrait by Rembrandt and two paintings by Renoir; *Conversation* (c. 1875) and *Young Parisienne* (1875). In total, the stolen art was worth $32 million/£26 million. However, the works were too readily identifiable for the thieves to be able to resell them and the black market was under especially close scrutiny following the robberies. Soon after the paintings were stolen, a ransom note demanding $3 million/£2.4 million was sent to the museum.

In January 2001, another ransom was passed to the police by a lawyer acting on behalf of the thieves. It demanded a sum of several million kronor, and was accompanied by photos of the paintings to prove that the ultimatum was genuine. The museum directors refused to pay. That month, two Russian villains, Alexander Petrov and Stefan Nordström, who had planned the heist, as well as the lawyer who acted as negotiator for them, and several other accomplices were arrested. Following the arrests, Petrov, Nordström and three others were put on trial and convicted seven months later.

Later still in 2001, the first of the paintings resurfaced. An unrelated drugs raid led to the chance discovery of *Conversation* concealed in a bag. Renoir's *Young Parisienne* was found in 2005 during the course of another drugs raid, while Rembrandt's self-portrait was discovered later that year in a hotel in Copenhagen, purportedly found by accident during an attempted sale when the police intervened. The recovery of all works of art stolen in a heist such as happened in this case is extremely rare.

BELOW, LEFT: *Young Parisienne*, Pierre-Auguste Renoir, 1875.

BELOW, RIGHT: This *Self-Portrait* by Rembrandt van Rijn was discovered in a hotel in 2005.

Van Gogh I

On 7 December 2002, thieves used a sledgehammer to smash a window of the Van Gogh Museum in Amsterdam. Inside, they grabbed two of his paintings: *View of the Sea at Scheveningen* (1882) and *Congregation Leaving the Reformed Church in Nuenen* (1884–85).

After a 14-year search and an investigation into a group linked to the Italian mafia, authorities recovered the paintings in Italy in 2016 in the home of an Italian drug-dealer.

In 2003, in Marbella, Spain, a man called Octave Durham was arrested, implicated in the crime through DNA evidence taken from strands of hair found in a baseball cap that was discovered after the heist. Durham served a 25 month prison sentence, but he refused to give the police any information about the whereabouts of the two paintings. Later, it was discovered that Durham and his accomplice, Henk Bieslijn, had sold the paintings to an Italian drug-dealer named Raffaele Imperiale. Thirteen years after Durham's arrest, Imperiale wrote to a public prosecutor in Naples, to say that he had bought the two paintings. Soon after, Italian police raided his family farmhouse

BELOW: The Van Gogh Museum in Amsterdam.

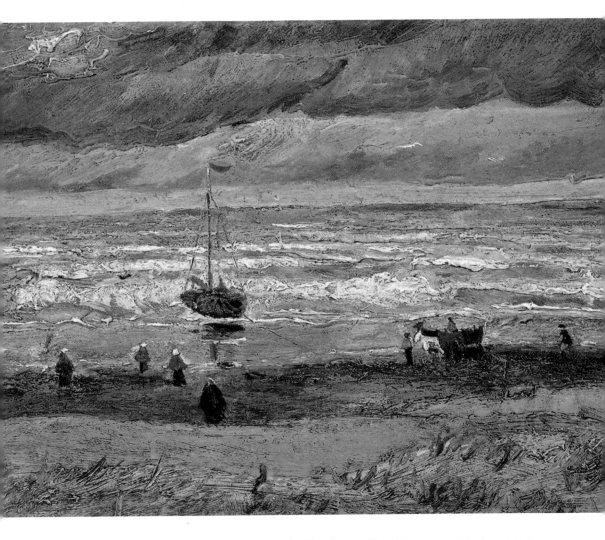

near Naples, where they found the paintings hidden in a wall cavity, wrapped in cotton sheets.

In a television documentary later made about the robbery, Durham said that the break-in took just 3 minutes 40 seconds and that he only snatched those two paintings because they were nearest to the window he broke through. The paintings were returned to the Van Gogh Museum. It took staff at the museum two years to assess the damage to the paintings and to undertake their restoration.

Congregation Leaving the Reformed Church in Nuenen was in good condition, but *View of the Sea at Scheveningen* had been damaged; a corner of the canvas was missing and had to be repaired.

ABOVE: *View of the Sea at Scheveningen*, Vincent van Gogh, 1882, which was damaged while it was in the hands of the criminals.

OPPOSITE: *Congregation Leaving the Reformed Church in Nuenen*, Vincent van Gogh, 1884-85 was thankfully returned unharmed.

LEFT: Policemen remove a rope used by thieves outside the museum.

BELOW: The paintings displayed by the delighted staff on their return to the museum.

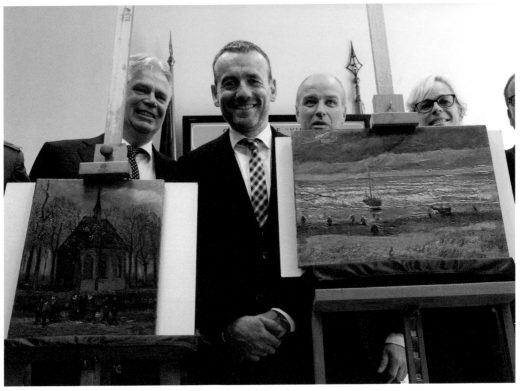

Left in the Lavatory

On 23 April 2003, officials at the Whitworth Art Gallery at The University of Manchester in England discovered that three of its most famous paintings, by van Gogh, Picasso and Gauguin, were missing.

Valued at an estimated $8 million/£6.4 million, the paintings were: *The Fortifications of Paris with Houses (The Ramparts of Paris)*, 1887, by Vincent van Gogh; *Poverty (Les Misérables)*, 1903, by Pablo Picasso; and *Tahitian Landscape*, 1891, by Paul Gauguin. Reports indicated the thief or thieves entered the Whitworth by ramming or battering the steel-covered doors at the rear of the building. The artworks were then snatched from the Margaret Pilkington room before anyone even noticed.

A few days later, an anonymous caller directed local police to an unused local public toilet, not far from the museum. There, in the corner, the police found a soggy cardboard tube in which the paintings had been rolled up. Next to it had been placed a note which read: 'We did not intend to steal these paintings, just to highlight the woeful security.' The slightly damaged artworks were soon repaired and returned to the gallery. The thieves were never found.

OPPOSITE: *Poverty (Les Misérables)*, Pablo Picasso, 1903.

BELOW: *Tahitian Landscape*, Paul Gauguin, 1891.

Switzerland to Serbia

It was daylight on 10 February 2008, when three men in ski masks entered the E. G. Bührle Foundation Museum in Zürich, Switzerland.

One of the men pulled a gun and forced museum staff and patrons to the floor, while the two others went into the exhibition hall and grabbed four paintings closest to the door. The men were described as not particularly tall, and one spoke German with a Slavic accent. Within minutes, they escaped the museum and sped off in a white van, leaving stunned museum visitors and employees still lying face-down.

The four stolen paintings were displayed behind glass and a security alarm went off as soon as they were touched. All extremely valuable and of great cultural importance, they were: Paul Cézanne's

OPPOSITE: *Boy in the Red Waistcoat*, Paul Cézanne, 1888-90.

BELOW: *Poppies near Vétheuil*, Claude Monet, 1879.

Boy in the Red Waistcoat, 1888–90; *Poppies near Vétheuil* (1879), by Claude Monet (1840–1926); van Gogh's *Blossoming Chestnut Branches* (1890) and *Ludovic Lepic and his Daughters* (1871) by Edgar Degas. It was one of the biggest art thefts ever to occur in Europe and the largest art robbery in Switzerland's history.

It seems that the men simply grabbed the paintings nearest to them, rather than selecting judiciously, as although at the time worth an estimated SFR180 million ($197 million /£158 million), the paintings were not the most valuable works in the collection. One of the world's best private art collections, the Bührle collection is especially rich in 19th century French Impressionist and Post-Impressionist works, with many by Cézanne, Degas, Gauguin, Manet, Monet, Pissarro, Renoir, Georges Seurat (1859–91), Alfred Sisley (1839–99), Toulouse-Lautrec and van Gogh, but also including art by Pierre Bonnard (1867–1947), Braque, Matisse and Picasso. Emil Georg Bührle (1890-1956) was a contentious figure who had made his fortune in the 1940s by manufacturing and selling arms to the Nazis, amassing profits amounting to 623 million francs, making him the

ABOVE: *Ludovic Lepic and His Daughters*, Edgar Degas, c. 1871.

LEFT: Interior of the E. G. Bührle Foundation Museum in Zürich, Switzerland.

richest man in Switzerland. He used this to help build his art collection. Other works in his collection were looted from Jewish collectors; they were either forced to hand over their artworks or had to sell them to raise the money to escape Nazi Germany. In 1960, the museum, or Foundation E. G. Bührle Collection (Stiftung Sammlung E. G. Bührle) was established by Bührle's descendants to make his art collection available to the public. It is housed in a villa adjoining Bührle's former home and contains 200 works of art. However, controversy continued.

For decades, the foundation was directed by Bührle's son Dieter, who received a conditional prison sentence of eight months for his part in sending weapons to support South Africa's racist apartheid regime.

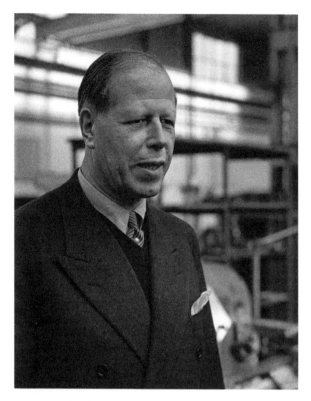

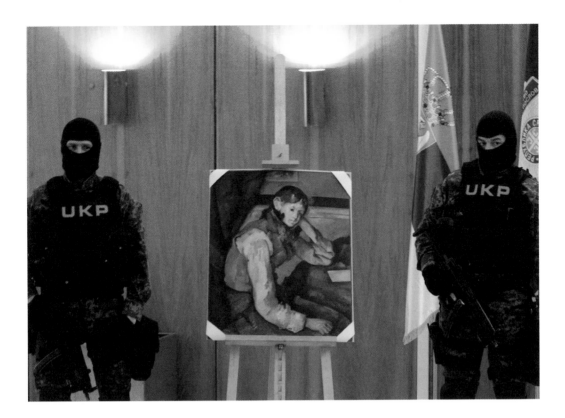

All four paintings stolen from the Bührle Foundation were eventually recovered. Monet's *Poppies near Vétheuil* and van Gogh's *Blossoming Chestnut Branches* were recovered eight days after the heist, on 18th February 2008, in a car parked in the grounds of a nearby psychiatric hospital. Cézanne's *Boy in the Red Waistcoat* was recovered in Belgrade, the capital of Serbia, two years later, on 12th April 2012 and Degas's *Ludovic Lepic and His Daughters* was also recovered that month, with slight damage where the thieves had tried to cut the canvas from the frame. That year, four men were arrested in Serbia in connection with the theft. They had been discovered after police had found the getaway vehicle and continued following the trail beyond Switzerland. The Swiss and Serbian authorities launched a huge operation that they codenamed 'Waistcoat'. It involved approximately thirty investigators from six countries as well as a vast network of undercover agents who also worked towards the eventual recovery of the works, by monitoring phones, tracking suspects' movements and performing other surveillance operations.

ABOVE: Policemen stand guard next to *Boy in the Red Waistcoat* by Cézanne in Belgrade after it was recovered.

OPPOSITE, TOP: Emil Georg Bührle, 1942.

OPPOSITE, BOTTOM: Policemen outside the E. G. Bührle Foundation Museum.

Van Gogh II

Painted in 1884 by van Gogh while he was living with his parents, *The Parsonage Garden at Nuenen*, also called *The Parsonage Garden at Nuenen in Spring* or *Spring Garden* is an oil painting on paper, mounted on a wooden panel.

From 1962, *The Parsonage Garden at Nuenen* was part of the collection of the Groninger Museum in the city of Groningen in the Netherlands, but in March 2020, it was on loan to the Singer Laren Museum in Laren for its *Mirror of the Soul* exhibition. This included more than 70 Dutch paintings, watercolours and drawings from the 19th century, but when the Covid-19 pandemic struck, the museum had to close.

RIGHT: *The Parsonage Garden at Nuenen*, Vincent van Gogh, 1884, oil on paper on panel, 25 x 57 cm (9⅞ x 22 in), Groninger Museum, Groningen, the Netherlands.

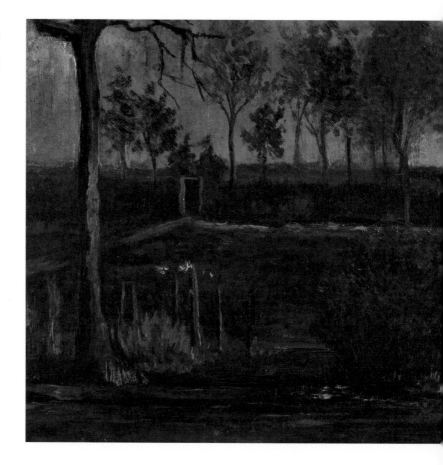

Then, one hundred and thirty-six years after it had been completed, on what would have been its artist's 167th birthday – 30 March 2020 – it was stolen.

In January 1882, soon after he decided to become an artist, van Gogh moved to The Hague where he lived with a prostitute, Sien Hoornik (1850–1904) and studied art with his cousin-in-law Anton Mauve (1838–88). He set up a studio and began painting in oils for the first time. Because he could not support Sien as he had promised her, she moved out, and van Gogh moved alone to Drenthe in the northern Netherlands. Between the end of 1883 and 1885, he lived with his parents in the parsonage of the Dutch Reformed Church at Nuenen near Eindhoven, where his father was pastor. The family turned the laundry room at the back of the house into a studio for him, and there, van Gogh produced nearly 200 drawings and paintings, many of the surrounding gardens and the façade of the parsonage. It was there that he painted his first major work, *The Potato Eaters* (1885). Van Gogh documented the changing seasons in his paintings of the walled garden of the parsonage, with its duck

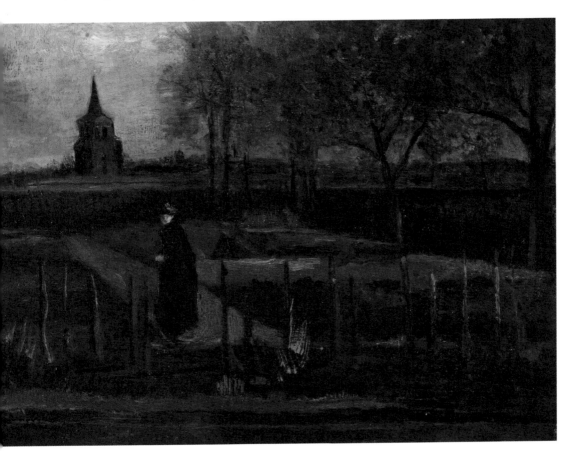

ABOVE: *Road Behind the Parsonage Garden in Nuenen*, Vincent van Gogh, 1884, ink on paper, Rijksmuseum, Amsterdam, The Netherlands.

pond, boat dock, flowers, vegetable plots, orchard and pathways. *The Parsonage Garden at Nuenen* comes in series after several drawings of the garden in winter, and it shows the spring emerging, and in the foreground a female figure dressed in black. In the distance can be seen the ruins of the old church before it was demolished in 1885. The colours represent van Gogh's early palette of dark greens and browns that emulated Dutch masters, such as Rembrandt. He wrote a letter in March 1884, describing his observations of the change in the seasons: 'I'm also searching for the colour of the winter garden. But it is already a spring garden – now. And has become something completely different.'

At around 3.15am on Sunday 30 March 2020, thieves broke through the glass front door of the empty Singer Laren Museum. They took just *The Parsonage Garden at Nuenen*. The burglar alarm was activated, but by the time the police arrived, the thieves had gone. The painting, estimated to be worth around €6 million ($6.4 million/£5 million), was immediately added to INTERPOL's international list of stolen works of art.

For three-and-a-half years, the artwork remained missing, and then, in September 2023, it was found. Arthur Brand, a Dutch art detective, who had already been nicknamed 'the Indiana Jones of the

art world' for his part in tracing several lost artworks, was instrumental in its recovery. When he confirmed that the painting was the stolen van Gogh he said it was 'one of the greatest moments of my life'. A man had contacted Brand saying that he wanted to give the painting back, but this person's identity was not revealed for his own safety. Brand said: 'The man told me, "I want to return the van Gogh, it has caused a massive headache."' He explained to Brand that the artwork was useless as a bargaining chip because it was so famous. Once he realised where the painting was being held, Brand convinced this unidentified man to bring it to him in Amsterdam. He insisted to the authorities that the man had nothing to do with the theft and he received the artwork, wrapped in bubble wrap, inside a large blue Ikea carrier bag.

Security footage has since been released from the Singer Laren Museum showing a disguised man leaving, carrying the painting under his right arm. It has been established that the thief was a known criminal, named by the media as Nils M. When the painting was recovered, he had already been caught and imprisoned for the crime – he had been handed an eight year sentence and a fine of €8.7 million ($9.3 million/£7.5 million). Another criminal, Peter Roy K, who prosecutors say probably ordered the theft in an attempt to negotiate his own reduced sentence, remained behind bars.

It seems that Nils M also stole another painting from a different town: *Two Laughing Boys with a Mug of Beer,* a c. 1626 painting by Frans Hals, that was in the Hofje van Mevrouw van Aerden museum in Leerdam, not far from Utrecht. Thieves or a single thief broke into the building from the back door. The painting has been stolen from the museum three times: in 1988, 2011 and 2020. It was first taken in 1988 along with a painting by Jacob van Ruisdael (c. 1629–82), but both paintings were recovered three years

ABOVE: *The Parsonage Garden at Nuenen in Winter,* Vincent van Gogh, 1884, ink on paper, Museum of Fine Arts (Szepmuveszeti) Budapest, Hungary.

later. Next it was stolen in April 2011 and returned six months later, that October. The third burglary of the painting was in late August 2020, the second theft of a painting from a Dutch museum that was closed due to the Covid-19 pandemic. The thief was arrested the following April. Neither painting was recovered at that time, although the van Gogh, as we know, was subsequently recovered. The Hals remains missing and the art detective Arthur Brand has said that he believed the painting was 'stolen to order'.

Two Laughing Boys with a Mug of Beer is a 'Kannekijker' in old Dutch, meaning a glutton, or a greedy person. The painting also represents one of the five senses – seeing – which means that it is likely that the painting was one in a series, with four others depicting the other four senses; hearing, taste, smell and touch. Arthur Brand has said that the person in custody for the theft probably did not know the location of the painting because 'stolen artwork is often moved around quickly by criminal gangs'.

LEFT: Dutch art detective Arthur Brand holding a centuries-old French reliquary that was stolen from the abbey de la Sainte Trinité in Fécamp, France in 2023, which he successfully recovered.

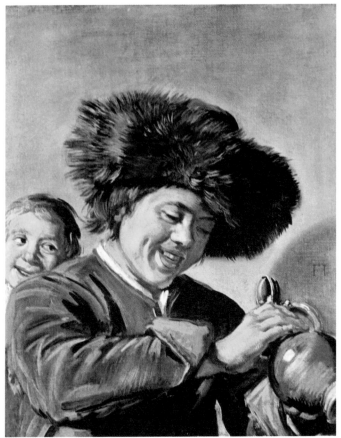

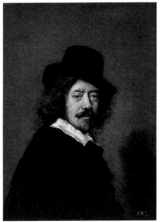

TOP: Façade of the Hofje van Mevrouw van Aerden, where *Two Laughing Boys with a Mug of Beer* was stolen.

BOTTOM, LEFT: *Two Laughing Boys with Mug of Beer*, Frans Hals, c. 1626, oil on canvas, 69 x 56.5 cm (27 x 22¼ in), Hofje van Mevrouw van Aerden, Leerdam, the Netherlands.

BOTTOM, RIGHT: *Portrait of the Artist*, Frans Hals, c. 1650, oil on wood, Indianapolis Museum of Art at Newfields, Indianapolis, USA.

Conclusion

Most criminals who steal works of art are ignorant of the art world, its histories and of artists, their techniques, materials, biographies and circumstances. Most simply know that the art is valuable and seemingly within reach. When artworks are ripped from walls or cut from frames, it is clear how little many thieves care or understand about value.

When art is stolen, part of our culture is taken away. Yet international art theft has become a big business, one of the top global crimes, with only an estimated ten percent of stolen art ever being recovered. Many nations operate police squads to investigate art theft, such as INTERPOL, the FBI Art Crime Team and London's Metropolitan Police Art and Antiques Unit. Occasionally, individuals take the law into their own hands. For example, Maria Altmann, née Maria Victoria Bloch, later Bloch-Bauer (1916–2011), a Jewish refugee from Austria, undertook a legal campaign to reclaim from the Government of Austria, five family-owned paintings by Gustav Klimt that were seized by the Nazis during the Second World War. After the war, the paintings were in the Austrian government's possession. They included two portraits of Altmann's aunt, Adele Bloch-Bauer,

BELOW: Nazi plunder stored in a church at Ellingen, Germany.

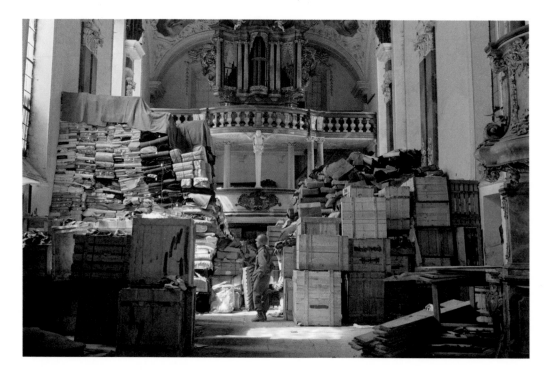

and ultimately, in 2006, it was ruled that Austria was legally required to return the paintings to Altmann and the other family heirs. This has fuelled many more conversations over artworks around the world that have been taken from one country to another over history.

Art is our escape, and the theft of great artworks can result in complex feelings of loss – as was made apparent by the queues of people who visited the Musée du Louvre in 1911 simply to view the space on the wall where the Mona Lisa had been before it was stolen. To this day, the places where the thirteen artworks and artefacts had been displayed in the Isabella Stewart Gardner Museum in Boston remain empty as a constant reminder of their loss. The hope remains that one day, these and many other stolen works will be recovered.

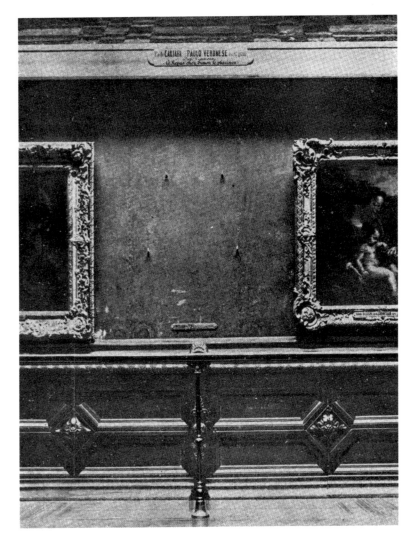

LEFT: The gap on the wall of the Carre Gallery of the Louvre Museum, Paris, where the *Mona Lisa* was exhibited before it was stolen in 1911.

Index

Picture credits

Key: t = top; b = bottom; l = left; m = middle; r = right; and variations thereof

7t David L Ryan/The Boston Globe/Getty Images; 7b Jacobs Stock Photography Ltd/Getty Images; 8 Wikimedia; 10l ©Isabella Stewart Gardner Museum/Bridgeman Images; 10r Universal History Archive/ UIG/Bridgeman Images; 11 Pictures from History/Bridgeman Images; 13 + 141 LiliGraphie/Shutterstock; 15tl, 15tm, 15tr, 15bl, 15br Wikimedia; 15ml DCOW/EUB/Alamy; 15mr History and Art Collection/Alamy; 16t Photo 12/Alamy; 16tr Heritage Image Partnership Ltd/Alamy; 16b Sueddeutsche Zeitung Photo/Alamy; 17 + 18t Pictures from History/Universal Images Group/Getty Images; 18bl Sueddeutsche Zeitung Photo/Alamy; 18r Wikimedia; 19 IanDagnall Computing/Alamy; 20 incamerastock/Alamy; 21 Vicimages/Alamy; 22 FineArt/Alamy; 23 Wikimedia; 25 Lawrence K. Ho/Los Angeles Times/Getty Images; 27t Zuri Swimmer/Alamy; 27b Niday Picture Library/Alamy; 29 Wikimedia; 30t Courtesy of theartnewspaper.com; 30b Historic Images/Alamy; 32t, 32b, 33t, 33b + 34t Associated Press/Alamy; 34b Roman Belogorodov/ Alamy; 35 History/Universal Images Group/Getty Images; 37 Tracy Carncross/Alamy; 38 aerophoto/Shutterstock; 39 Peter Horree/ Alamy; 40t ermess/Shutterstock; 40b JOHN KELLERMAN/Alamy; 41 Zuri Swimmer/Alamy; 43 Heritage Image Partnership Ltd/ Alamy; 44 Riccardo Lombardo/REDA&CO/Universal Images Group/Getty Images; 45t ARCHIVIO GBB/Alamy; 45b Prachaya Roekdeethaweesab/Shutterstock; 46 Album/Alamy; 47t The Picture Art Collection/Alamy; 47b Enzo Brai/Mondadori/Getty Images; 48 FILIPPO MONTEFORTE/AFP/Getty Images; 49t Associated Press/ Alamy; 49b Marka/Universal Images Group/Getty Images; 51t David Giral/Alamy; 51b ColsTravel/Alamy; 52tl Wikimedia; 52tr Niday Picture Library/Alamy; 52bl The Picture Art Collection/Alamy; 52 br Wikimedia; 53t, 53ml Heritage Image Partnership Ltd/Alamy; 53mr Lefevre Fine Art Ltd., London/Bridgeman Images; 53b Wikimedia; 54 Bettmann/Contributor/Getty Images; 55 Courtesy of Montréal-Matin L'illustration Nouvelle, 1941; 56t Melchior DiGiacomo/Getty Images; 56b Courtesy of ctvnews.com; 57 Historic Collection/Alamy; 59 © Tate; 60l PA Images/Alamy; 60r © Hulton-Deutsch Collection/ CORBIS/Corbis/Getty Images; 61 + 62 Bridgeman Images; 63 © Tate; 65t Associated Press/Alamy; 65b Renata Tyburczy/Alamy; 66tl FAMOUS PAINTINGS/Alamy; 66tr, 66mr, 66bl, 66br © Isabella Stewart Gardner Museum/Bridgeman Images; 66ml Vital Archive/ Alamy; 67tl Wikimedia; 67tr © Isabella Stewart Gardner Museum/ Bridgeman Images; 67ml, 67b The Picture Art Collection/Alamy; 67mr Wikimedia; 68 + 69t, 69b Everett Collection Inc/Alamy; 70l, 70r Bettmann Archive/Getty Images; 71tl, 71tm, 71tr Associated Press/Alamy; 71ml Everett Collection Inc/Alamy; 71mm Jonathan Wiggs/The Boston Globe/Getty Images; 71mr Tom Landers/The Boston Globe/Getty Images; 71b Mark Garfinkel/MediaNews Group/ Boston Herald/Getty Images; 72t Bettmann Archive/Getty Images; 72bl Associated Press/Alamy; 72br Tom Herde/The Boston Globe/ Getty Images; 73 Associated Press/Alamy; 74 Everett Collection Inc/Alamy; 75 © Isabella Stewart Gardner Museum/Photo © Sean Dungan/Bridgeman Images; 77 Heritage Image Partnership Ltd/ Alamy; 78 Pictures Now/Alamy; 79 + 80 Wikimedia; 81t, 81b PA Images/Alamy; 83 © David Lees Photography Archive/© The Henry Moore Foundation. All Rights Reserved, DACS 2024/www.henry-moore.org/Bridgeman Images; 84 Heritage Image Partnership Ltd/ Alamy/DACS 2024; 85t Keystone Press/Alamy/DACS 2024; 85b © The Lewinski Archive at Chatsworth. All Rights Reserved 2024/© The Henry Moore Foundation. All Rights Reserved, DACS 2024/www. henry-moore.org/Bridgeman Images; 87 PA Images/Alamy/DACS 2024; 88t Courtesy of Manchester Evening New/DACS 2024; 88b PA Images/Alamy/DACS 2024; 89t Tyne & Wear Archives & Museums/©

Estate of Fred Yates. All rights reserved 2024/Bridgeman Images; 89b Courtesy of Manchester Evening News/DACS 2024; 90t, 90br PA Images/Alamy; 90bl Chris Bull/Alamy; 91t Tony Evans/Getty Images; 91b steeve-x-art/Alamy/DACS 2024; 93tl © Succession Picasso/DACS, London 2024/Bridgeman Images; 93tr © Succession H. Matisse/ DACS 2024. Photo: Bridgeman Images; 93ml © Christie's Images/ Bridgeman Images/DACS 2024; 93mr Bridgeman Images/DACS 2024; 93b Wikimedia; 94 + 95t Associated Press/Alamy; 95b BERTRAND GUAY/AFP/Getty Images; 96l, 96r + 97 Associated Press/Alamy; 99 Maidun Collection/Alamy; 100t Sipa US/Alamy; 101b MikeDotta/ Shutterstock; 101t Barry Iverson/Alamy; 101b KHALED DESOUKI/ AFP/Getty Images; 102t Brastock/Shutterstock; 102b Jonathan Rashad/Getty Images; 103 Insights/Universal Images Group/Getty Images; 105t Image Professionals GmbH/Alamy; 105b Hercules Milas/ Alamy; 106t, 106b Wikimedia; 107t Associated Press/Alamy; 107b Peter Jordan_NE/Alamy; 108t Nhu Hoang/Shutterstock; 108b + 109 Durham Police; 110 Apostolis Giontzis/Alamy; 111t Xinhua/Alamy, 111b + 112 Béatrice Lécuyer-Bibal/Gamma-Rapho/Getty Images; 113l, 133r + 114 RMN-Grand Palais/Gèrard Blot/RMN-GP/Dist. Foto SCALA, Florence; 113m Xinhua/Alamy; 115 + 116-17 Wikimedia; 119 Barbara Hepworth © Bowness, photo: Ben Sutherland; 120t Jono Photography/Shutterstock; 120b RichardBaker/Alamy; 121t © Peter Kinnear Photography. All rights reserved 2024/Bridgeman Images; 121b AC Manley/Shutterstock; 123tl © The Lucian Freud Archive. All Rights Reserved 2024/Bridgeman Images; 123tr History and Art Collection/Alamy; 123bl Carlo Bollo/Alamy; 123br Associated Press/ Alamy; 124 + 125tl Associated Press/Alamy; 125tr, 125bl, 125br WENN Rights Ltd/Alamy; 126-27 Associated Press/Alamy; 128t DANIEL MIHAILESCU/AFP/Getty Images; 128b + 129l, 129r Associated Press/ Alamy; 131 American Photo Archive/Alamy/DACS 2024; 132t Daniel Staniszewski/Alamy; 132b Science History Images/Alamy; 133 Peter Barritt/Alamy/DACS 2024; 134tl Stimmungsbilderl/Alamy; 134tr, 134bl, 134br Album/Alamy © The Andy Warhol Foundation for the Visual Arts, Inc./DACS 2024; 135 Associated Press/Alamy; 137 incamerastock/Alamy; 138 History and Art Collection/Alamy; 139 Bridgeman Images; 141 + 142 Wikimedia; 143 Marc Anderson/ Alamy; 144tl, 144tr Wikimedia; 144b Albert Harlingue/Roger-Viollet/ Getty Images; 145t Roger-Viollet/Getty Images; 145b AFP/Getty Images; 147t Sergio Azenha/Alamy; 147b Pigprox/Shutterstock; 149 + 151t Wikimedia; 151bl Nowaczyk/Shutterstock; 151br Ian Dagnall Commercial Collection/Alamy; 152 Bridgeman Images; 153l, 153r Wikimedia; 154 Stefano Guidi/Getty Images; 155 + 156 handout/ Getty Images; 157t TOUSSAINT KLUITERS/AFP/Getty Images; 157b MARIO LAPORTA/AFP/Getty Images; 158 Courtesy of Whitworth Art Gallery/Getty Images; 159 Whitworth Art Gallery / © Succession Picasso/DACS, London 2024 / Bridgeman Images; 160 Album/ Alamy; 161 Bridgeman Images; 162 PAINTING/Alamy; 163t History and Art Collection/Alamy; 163b AGF Srl/Alamy; 164t Photopress Archiv/Keystone/Bridgeman Images; 164b Courtesy of art-crime. blogspot.com; 165 Associated Press/Alamy; 166-67 Album/Alamy; 168 + 169 Bridgeman Images; 170 ANP/Alamy; 171t Wolf-photography/ Shutterstock; 171bl steeve-x-art/Alamy; 171br GL Archive/Alamy; 172 Pictures from History/Bridgeman Images; 173 Chronicle/Alamy.